To

"Mirzoeff deftly dissects the violent abstractions that are characteristic of the drone's remote-controlled gaze, arguing incisively for a return to ways of seeing that are grounded in solidarity and resistance."
— Candice Breitz, video and photography artist

"Mirzoeff sharply urges us to divest from a mere spectatorship to a genocide, and insists that we see in relation, in solidarity and as an anti-colonial collective. *To See In the Dark* is to settle for no less than to see Palestine free."
— Simone Browne, author of *Dark Matters: On the Surveillance of Blackness*

"If ever we ever needed a contemporary rejoinder to John Berger's *Ways of Seeing*, this is the book. Timely and clearly written, *To See In the Dark* is a manifesto to solidarity, a foraging, salvaging and a way to unset alongside the opaque lives of Palestinians, who struggle under organized, genocidal state violence."
— Stephen Sheehi, co-author of *Camera Palaestina: Photography and Displaced Histories of Palestine*

VAG ABO NDS

Radical pamphlets to fan the flames of discontent
at the intersection of research,
art and activism.

Series editor: Max Haiven

Also available

001
*Pandemonium: Proliferating
Borders of Capital and the
Pandemic Swerve*
Angela Mitropoulos

002
*The Hologram: Feminist,
Peer-to-Peer Health for a
Post-Pandemic Future*
Cassie Thornton

003
*We Are 'Nature' Defending Itself:
Entangling Art, Activism and
Autonomous Zones*
Isabelle Fremeaux
and Jay Jordan
Published in collaboration
with the *Journal of Aesthetics
& Protest*

004
Palm Oil: The Grease of Empire
Max Haiven

005
*On Cuddling: Loved to Death in
the Racial Embrace*
Phanuel Antwi

007
*Pirate Care: Acts Against the
Criminalization of Solidarity*
Valeria Graziano, Marcell
Mars and Tomislav Medak

006

To See In the Dark

Palestine and Visual Activism Since October 7

Nicholas Mirzoeff

PLUTO PRESS

First published 2025 by Pluto Press
New Wing, Somerset House, Strand, London WC2R 1LA
and Pluto Press, Inc.
1930 Village Center Circle, 3-834, Las Vegas, NV 89134

www.plutobooks.com

British Library Cataloguing in Publication Data
A catalogue record for this book is available from the
British Library

ISBN 978 0 7453 5115 5 Paperback
ISBN 978 0 7453 5117 9 PDF
ISBN 978 0 7453 5116 2 EPUB

This book is printed on paper suitable for recycling and
made from fully managed and sustained forest sources.
Logging, pulping and manufacturing processes are
expected to conform to the environmental standards of
the country of origin.

Typeset by Stanford DTP Services, Northampton,
England

Simultaneously printed in the United Kingdom and
United States of America

Contents

List of Figures vi

Introduction: "Palestine Is the World" 1

To See In the Dark 36

Rubble 62

Autopsy 77

Slash the Screen 102

Encampments 112

Coda: A Murmuration for Rosa 124

Notes 138

List of Figures

Photo by author or unknown family member unless credited otherwise.

1. Shahuda Street checkpoint, Hebron 22
2. Erez Checkpoint, Gaza, photographed from a moving vehicle 24
3. Checkpoint on the NYU campus at Gould Plaza 25
4. Claire Fontaine, "Foreigners Everywhere" (2024) 31
5. The Israel Pavilion, Venice Biennale, 2024 32
6. Rose petal memorial for women killed in Gaza, Venice, April 2024 33
7. The Freedom Boat moored in Venice with a poetry reading in progress 34
8. Abraham Bosse, "Perspective" (1648) 37
9. US Field Manual 3-09.34 "Blue Kill Box" (Public Domain) 39
10. Sensitive content logo on Instagram 51
11. Instagram post QR code Zein Rahma, May 12, 2024 57
12. Instagram post QR code Everyday Palestine, May 15, 2024 58
13. Instagram post QR code Mosab Abu Toha, May 13, 2024 59
14. Instagram post QR code Ali Jadallah, June 14, 2024 60

15. Jean Mohr, "Hebron. Most Palestinian refugees live in tents. The ICRC sets up the first schools" (1950). Photo: International Committee of the Red Cross (public domain) 66

16. Instagram post QR code Mosab Abu Toha, June 6, 2024 69

17. Site of former Mirzoeff family house in Mea Sharim, Jerusalem (2016) 81

18. Pnina Asheroff with family in Palestine (front row, center) 1920-30s. Photographer unknown 82

19. Pnina Asheroff in Palestine 83

20. Anon, "Slashed Balfour." Photo via Palestine Action, 2024 102

21. Instagram QR code Palestine Action, March 8, 2024 109

22. Birdcage in a Hebron market, 2016 126

23. QR Code Haneen Maheer, posted June 3, 2024 127

24. Harry Topper (second from left) outside his shop, c. 1960 129

VI

TO SEE IN THE DARK

Introduction:
"Palestine Is the World"

On March 28, 2024, feminist activist and thinker Silvia Federici told a packed house in New York City: "Palestine is the world."[1] She had said this before, yet her words landed differently in the wake of Hamas' attack in Israel on October 7, 2023, and the subsequent onslaught by the Israel Defense Forces (IDF) on Gaza. As Federici's words reverberated intensely around the great hall at Performance Space on First Avenue, they were repeated by every other speaker there. I still see the effect that these words have on people when I've quoted them.

There are two key inflections in the phrase "Palestine is the world": to think Palestine globally; and to see it in an anti-racist, decolonial, and feminist framework. To see Palestine from the "outside" is not to speak for Palestinians but to associate with them in the global solidarity movement that has become a form of intifada (uprising) in its own right.

Speaking in Paris that same March, feminist philosopher Judith Butler noted how politics have realigned: "Feminism, queer mobilization, trans mobilization have to all be in solidarity with Palestine now, because we all suffer from forms of state and regulatory violence that makes our lives unlivable or makes us have to fight for our lives."[2]

Unlivable lives are nowhere more evident than in Gaza.[3] In 2012, the UN said that without herculean efforts, which were not forthcoming, life there would become unlivable by 2020.[4] As I write, it's four years past that. Since Israel began its systematic effort to eliminate the possibility of Palestinian life in Gaza, over 40,000 people have been killed and a staggering 90,000 wounded, many of whom have suffered amputations and other disabling injuries.[5] The authoritative British medical journal *The Lancet* estimated in July 2024 that at least 186,000 "indirect" deaths would result from disease, injury, hunger, and other causes.[6] State violence has made the lives of Palestinian people unlivable.

The Word

I'm Jewish and I'm anti-Zionist. It has never been an easy position to sustain. That trouble is minimal by comparison with that of Palestinians, yes, absolutely. To be an anti-Zionist Jew requires overcoming the combined efforts of the state of Israel, Zionism, and white supremacy to make this identity impossible. For the US magazine *The Tablet*, anti-Zionists like me are "un-Jews."[7] Ironically, this echoes the designation of Palestinians under the 1917 Balfour Declaration that first committed to a Jewish state.[8]

I've experimented with writing myself as a "jew," spelled in all lower-case letters. The "proper" Jews, the nationalists and Zionists can have the proper noun and its upper case of hierarchy. I'm a common or garden-variety jew. You can

see the difference. But as some may be listening to the audio version of this text, I won't adopt that lower case throughout. This book is about seeing, not writing. How can I see or watch this genocide as an anti-Zionist? As a Jew? From what place can you and I watch it as anti-Zionist Jews? What does that do? Not for us, but for the movement?

In watching Gaza, alongside what would otherwise be exceptional levels of violence in the West Bank and Lebanon, all equivocation to the contrary, I see a genocide.[9] Words matter. Jewish Voice for Peace warned of genocide on October 11, 2023.[10] I was convinced by Israeli historian Raz Segal, writing in *Jewish Currents* on October 13, 2023, that this is "a textbook case of genocide."[11] Israeli activist group Zochrot first described events as the "Gaza Nakba" and came to use the word "genocide" by the end of 2023.[12] While many have tried to argue that it is antisemitic to use this word at all, this is a substantial assembly of Israelis and Jews to ignore.

I take genocide to mean, as political theorist Nasser Abourahme puts it, "the intentional destruction of a people's capacity to exist."[13] I cannot adjudicate the debate in law.[14] I know what I'm seeing, nonetheless. For others, that saying must be prohibited and the seeing denied.

Even the slow-moving and cautious International Court of Justice has now found genocide in Gaza to be "plausible." Abourahme sees the effort of destruction as beginning with the Nakba in 1948, the mass displacement and dispossession of 750,000 Palestinians from their historic homes, resulting in 15,000 deaths.

People have hesitated to use the word "genocide" because, as no less a scholar than Didier Fassin, professor at the elite Collège de France, found when writing about Gaza as an expert in genocide studies: "the deterring rhetoric is extraordinarily powerful." He cited research showing that 98% of assistant professors and 76% of full professors "self-censor" when discussing Palestine.[15] For ordinary professors, it's not just rhetoric—there is a realistic fear of dismissal or other sanction, not to mention the excoriating fury and violence from the internet.

In her 2024 "Afterword: On Gaza," British-Palestinian writer Isabella Hammad points out: "In dominant Western discourse, genocide can only be committed against the Jews because it once was, and therefore they are the only group that must be protected."[16] By definition, in this view, there cannot be a genocide in Gaza.

According to the historian Patrick Wolfe, settler colonialism is a structure not an event. It is organized around what he called "the settler-colonial logic of elimination [which] has manifested as genocidal . . . Settler colonialism is inherently eliminatory but not invariably genocidal." It "destroys to replace." [17] Israel's long strategy of elimination is now inescapably genocide.

One can debate the word or words that apply to what Hamas did on October 7, 2023. Isabella Hammad called it "an incredibly violent jailbreak."[18] But it cannot be called a genocide. The Israeli actions in its aftermath combined eliminating tactics like removal and bombing with immediate and sustained denials of food, water,

medical treatment, and energy, the word for which is genocide.

The Visible

Federici's phrase, "Palestine is the world," resonated with me in a particular way. In 2015, I had written a book called *How To See The World*, which called on researchers to engage in visual activism.[19] It's impossible to assess the totality of visualized materials today—400 hours of YouTube video every minute, 1.9 trillion photos worldwide this year alone.

Following the lead of artists like South Africa's Zanele Muholi, I argued in 2015 it was instead time to activate the visible. That meant refusing the passive visible, composed of advertising, brands, influences, logos, and all that goes with them. In its place, there is a collective activation of what I more recently called "visible relation."[20] This relation has three components. It centers around the right to look, in which I allow you to look at me and you allow me to look at you. When this happens, what comes into being between us is common, not individual property. It's friendship, solidarity, and love. This is unrepresentable.

By the same token, there is the right to be seen in the way of your own choosing. Muholi's *Faces and Phases* project has claimed this right by collecting portraits of South Africa's LBGTQ people being seen on their own terms, despite systemic homophobia and transphobia.

Finally, there is what Martinican philosopher Édouard Glissant called "the right to opacity,"[21]

meaning the right to refuse to be seen, to engage with others without being placed under surveillance, whether from the heteropatriarchal male gaze, the colonial white gaze, or today's automated machine surveillance.

The visible that results from the performance of these three rights—claimed as if they were lawful with no regard for what the police may say—is relational, which Glissant called "the conscious and contradictory experience of contacts among cultures."[22] This relation is never singular, and it is never simple, but it is always intersectional.

It relies on what Glissant called the "consent not to be a single being,"[23] a mantra also evoked by Black radical thinker and poet Fred Moten as the title of his recent trilogy.[24] That's easy to say and hard to do. In this case, it involves my working through the relations of association and dissociation that Gaza has (re)activated.

Majority rule

Structural changes have made this visible relation and consent not to be a single being newly possible. In 2015, I pointed to the emergence of a new global majority, who are under 30, live in cities and have internet access. Since 2011, there have been repeated initiatives by that majority to claim democratic power in mobilizing responses to visual materials, from Tahrir Square via Occupy Wall Street to Black Lives Matter, #metoo, and many others.

While listening to Federici, it became obvious that the Gaza solidarity movement, soon to

create encampments worldwide, was the latest and perhaps most dramatic of these responses.[25] To adapt my earlier title, today to see Palestine is to see the world. To "see" Palestine means to act in support of its freedom. It is a particular kind of seeing that I will call seeing in the dark. Seventy-five years after the Nakba, European and US-based thinkers have begun to see the world from Palestine's point of view, rather than seeing Palestine from the world's point of view. From there, it becomes apparent that, as Abourahme puts it, "Palestine is everywhere because it names a political subject of radical universal emancipation."[26]

Gaza's people epitomize the global majority. The Gaza Strip is a densely populated city region, where half the population are under 18 and fully 70% are under 30. Its 2.3 million people live in an area the same size as Detroit, home to 620,000 people. Its inner-city regions like Gaza City or Khan Younis have the population density of a major Asian city.

Internet access in Gaza before October 7th was a remarkable 95%, even though much of it was on 2G networks. Afterwards, it dropped to single digits in some regions. Using workarounds like eSIMs—a virtual SIM card that allows access to mobile networks, often in Egypt—Gaza's media professionals and residents alike nonetheless found ways to document the unthinkable devastation meted out by Israel.

This change expresses the material and historical contradictions of visible relation today.[27] Distributed, platform-based digital media are

being used in the twenty-first century to watch a nineteenth-century "small war," the violent repression of dissent by a colonial power within what it takes to be its domain.[28] Israel is enacting a "punitive expedition," as British imperialists used to call it, in accord with its British colonial legacy.

But the massacre can now be seen as it happens, live. As a result, Palestine has become widely understood as a settler colony, even though the term has been contested by Israel's supporters.[29] Extractive media platforms, run by giant corporations like Alphabet, Meta, and Tiktok, have unintentionally enabled the global majority to see what colonialism looks like. Meta, in particular, have often tried to prevent Gaza from appearing on their platforms, but their own interfaces make that task difficult. This distributed, networked way of seeing is at once contained within the extractive machine of social media, while also working against it.

Seeing In the dark

Seeing is never simple. Under what Palestinian legal scholar Nadera Shalhoub-Kevorkian calls "the occupation of the senses,"[30] it is always a potential act of refusal and resistance. As visual theorist Gil Hochberg has explained, challenging the occupation has long required:

> the manipulation of visual positions, new settings for spectatorship, new modes of appearance, and at times new modes of disappearance, concealment, or refusal to appear. It

also involves the ability to see one's own blind-
ness and render visible one's failure to see.[31]

The first "turn" in this revolution since October
7th has been to end what visual theorist Ariella
Aïsha Azoulay called the "optical paradox" of the
state of Israel, as formed in 1948. This phrase cir-
culated in the early years following the Nakba and
referred to the supposed contradiction of modern
uses being made of "Oriental" buildings. More
importantly, as Azoulay says, "talk of this 'optical
paradox' didn't allow the real paradox to appear:
free citizens alongside others subordinated to
military rule."[32]

To refuse that hierarchy, inside and outside Pal-
estine, engages ways of seeing outside and against
settler-colonialism that I call "seeing in the dark."
The dark is the time-space outside the glare of
permanent surveillance. Seeing in this dark allows
for a movement from dissociation to association.
In direct terms, it's the move from the dissociative
"what can you do?" to the associative "what can
I/we do?"

The dark's material ground is rubble. Rubble
has its own scale from the saturating grey dust
that covers everything, to the broken pieces of the
built environment that entomb the living and the
dead, and the rubble of words and images. To see
in the dark is a refusal of the occupation's "will
to rubble."[33] It's also knowing that this rubble of
words and video fragments is a way to explore the
collective unconscious—the space that is "dark"
to the individual but structures what they say, see
and do.

To learn how to see in the dark, you have to cut and break the colonial viewing screen, whether a painting or an iPhone. This seeing refuses to be singular, whether a data point or the one-eyed viewpoint of linear perspective. It is an embodied, binocular, yet divided seeing. One eye sees through tears, the other attempts to take the measure of what is seen. The mediated form of this seeing is video. More exactly, it's data visualizations, from the "still" turned into what used to be called a photograph, to the short video posted online, and the multi-screen art installation. This video is scattered across platforms like rubble.

Professional photographers refer to their tools as "data gathering devices" not cameras. The data collected is rendered into something visible to people using software like Photoshop that works in layers. These layers may or may not be visible in the final output, but they are nonetheless present and can be excavated in reverse. Taking this as the metaphor it obviously is, what is seen in the dark contains different moments in time and space: what is past, what is hidden, what is invisible, what remains, what presents. This dark is personal as well as political. What's dark for us individually can be complex. It involves that which we might rather forget or have repressed. Seeing in the dark is hard because it requires us to see in both modes.

In the dark, "reality is not a given" advised the radical thinker and art critic John Berger. Rather, "it has to be continually . . . salvaged."[34] Visual activism today is scavenging rubble, whether fragments of words, found video, or material form. It requires what Berger later called the "unde-

feated despair" that he witnessed in Palestine.[35] Remember, too, that what fascism seeks to create above all in its opponents is defeated despair.

Thinking about this idea of seeing in the dark after October 7th, I learned from Isabella Hammad of the experimental play *Al-Atmeh* (*Darkness*), produced in Palestine by Hungarian director François Abu Salem in 1973 with the Al-Balalin troupe. As Hammad describes it, the play:

> revolved around a blackout in the theatre which the cast involves the audience in trying to fix. The titular darkness allows the actors to discuss the darknesses of various interrelated forms of oppression—occupation, social backwardness, patriarchy—and the play ends with the cast and audience holding candles to collectively illuminate the stage.[36]

This play prophetically expressed exactly what I am working toward: darkness is the place in which the operations of colonial oppression can be "seen," which also means heard, felt, touched, and other embodied perceptions.

The dark is a place of sound and what poet and revolutionary thinker Fred Moten calls "sounding," meaning an "[o]scillation, bridging over to leaping forward, jumping into."[37] Into freedom. The play, *Darkness*, ended with candles being passed round for audience and cast alike to hold, creating what the founder of Jenin's Freedom Theatre, Juliano Mer-Khamis, called: "a model society. Along the way, the process rebuilds

the communication tools that have broken down as the society has been broken."[38] Dissociation passes via darkness into association. Once activated, seeing in the dark teaches "how to be in the negative and in the loss."[39]

When activated in solidarity with others, creating visible relation, this salvage can become a grounded and collective practice. And in turn that grounded and collective practice can become a movement, as it did in the global intifada for Gaza. The experience is, of course, unknowably different inside Gaza. I can only see Palestine from "outside," geographically and culturally. This "outside" is nonetheless one of the key places to which the social media documentation of the violence in Gaza was and is directed.

As Jews

To add to these contradictions, like all politics, visual politics is always personal. After October 7th, I found it hard at first to look at the video coming out of Gaza. Not because of some squeamishness about violence but because I knew I shared responsibility, all disclaimers aside, for this killing being done in my name, as a Jew. And I felt shame.

It wasn't just me. Cartoonist Joe Sacco, author of the classic *Palestine* and *Footnotes on Gaza*, nonetheless admitted that his "initial response . . . was paralysis."[40] Arielle Angel, editor of the anti-Zionist *Jewish Currents* magazine, wrote of her grief but also of "an enormous failure of our movements."[41] All the activism, all the

theory, all the work had failed. We had failed, as people in solidarity, yes, but awkwardly and uncomfortably—for me—as Jews.

What fails here is not anti-Zionism but the effort to suture it to being a "Jew." To borrow from French feminist Luce Irigaray, the anti-Zionist is a Jew that is not one (under post-1948 conditions). Israel's laws define the state as for Jews only. That apartheid would have to end, there would need to be a right of return for Palestinians—in short, a free Palestine—for it to be possible to be an anti-Zionist Jew as such.

Israel's violence since October 7th reverberated by association with legacies of domestic, political, and sexual violence within my Jewish family.[42] To anticipate just one of these points: my grandmother had participated in Zionist armed conflict against the British in Palestine. Her work involved assembling weapons in the dark. This is part of the dark from which I have to see.

My own dark is another story . . . we'll get to it. It's here because it makes the systemic violence that enabled it visible.

These histories have meant that I held being Jewish at arm's length, calling myself something like "a person of Jewish descent." Such equivocations are no longer possible. The filmmaker Alex Juhasz put it perfectly: "something unthinkable has dawned. I am a Jew. I have been made Jewish."[43] As soon as I heard her say that, I realized it was true for me as well.

I am the descendant of four Jewish grandparents, all migrants and refugees. My Jewish credentials cover the map: refugees from Russia,

those who did not survive the concentration camps and those who did, Zionist fighters, settlers in Palestine both religious and secular, intellectuals, film makers, musicians, and actors. Because of this history, I am intensely aware of the practices of antisemitism. And still, I am an anti-Zionist Jew.

Previously, if I were to say, "I am a Jew," it did not feel like "me." I now feel bound in a certain paradox: that this hailing and deployment of me as a Jew in the context of the new instrumental philosemitism—always directed toward making Jews and the state of Israel indistinguishable—cannot be disavowed until there is freedom for Palestinians. It's not for nothing that people say, "none of us is free till all of us are free."

This is my road toward that freedom. I can only walk along it by decentering myself. There is no way to avoid the contradiction. Rather, as Palestinian poet Kaleem Hawa has put it, for anti-Zionist Jews, the task is to create "Palestinian freedom, which necessarily requires a militancy in withdrawing, confronting and creating contradictions."[44] Within institutions like universities, for example. And the institution of identity.

One such contradiction should be confronted. There has been an insistent demand for condemnation. While each person's death brings a world to an end, I think there has been enough condemning. There is mourning, though. I shall speak of nothing else.[45]

Because of my family connections, I had visited Palestine as a teenager. I felt none of the expected, almost required, identification. The 1982 Israeli invasion of Lebanon shook me into active refusal

of it. In the aftermath, I read Edward Said. I even met him once.

It was not until I visited the West Bank in 2016, guided and enabled by activists from Aida refugee camp in Bethlehem, that I fully realized the intensity and violence of the occupation.

Seeing the apparatus of colonization from the Wall to the checkpoints, there was no mistaking Israel's intent to eliminate all Palestinian life, whether by excluding them from the territory, by making social life of all kinds impossible, or by violence.

Even as it was obvious to everyone that I was a Jew, in Palestine I was treated with kindness everywhere I went. It was humbling to be offered hospitality by people reduced to destitution in my name.

It was difficult to discover that at some unsuspected level I had retained hopes or fantasies that a "solution" could be found, when the massive facts of settlement and segregation visibly made that impossible.

I went back to the beginning and wrote an "ABC of Occupation."[46] While I hope it may have been useful for others, the first pupil it taught was me.

As a result, in common with many other Jews, I have never equated criticism of Israel with antisemitism. This concept has been long pushed by Israel's apologists, and it has been saddening to see Jewish organizations in Britain and the US promote it. Membership organizations like Jewish Voice for Peace have made anti-Zionist Jewishness very visible since October 7th. This internal dis-

cussion among Jews is both very Jewish and shows that there is no one way to be Jewish.

To see in the dark is to see outside and against colonialism, against both antisemitism and the McCarthyism of the new censorious anti-antisemitism.

Association and Dissociation

As you liberate yourself in metaphor, think of others
(those who have lost the right to speak)
As you think of others far away, think of yourself
(say: "if only I were a candle in the dark").[47]
—Mahmoud Darwish, "Think of others."

To walk that road means taking personal and political steps. My analysis here of global power in Palestine via aerially guided assault, surveillance, and visual media intersects with my autotheory of violence.[48] In other words, I use myself—or more exactly, my selves—as a case study, as one means to understand what can appear to be beyond understanding at times.

State violence seeks to dissociate each person into an isolated individual to break up possible ways of seeing collectively. When activists so often ask of depictions of violence, "why don't people see this?" it is often because they can't—not physically, but psychically.

Dissociation is the means by which mediated subjects survive in a hyper-violent world. An openness to all violence would lead to constant mourning, so modern people have developed a mental shield to ward off that response. Violent

films and other media accustom the viewer to such shocks, as Walter Benjamin argued in the face of Nazism.[49] The risk is that we dissociate so much that what is seen is not registered.

On October 7th itself, it was at once clear that there would be massive reprisals by Israel. This anticipation was at once a recognition of colonial violence and a mode of dissociation, as if there was no alternative to violence, or that it could not have been prevented.

Association is also two-fold. It leads a person to perceive the suffering of others without focusing on our own feelings. In order to change that situation, we then associate with others in cultural, political, and social groups.

It is not motivated by simple empathy, like the photos used in charity or NGO appeals, but, as art historian and critic Aruna d'Souza has suggested, by the complicated duty of care.[50] Using this active engagement, dissociation can be unbuilt into new forms of association, such as the Gaza solidarity encampments on college and university campuses that sprang into being worldwide in April 2024.

These are ways of "doing things with being undone," as the artist and critic Jill Casid puts it.[51] It is a visible movement from dissociation to an active association.

Without at first knowing I was doing so, this staying with being undone has shaped a visual research method for this project. All the pictures are taken by me, researched in archives by me, or are part of my family photo archive. It was this set of personal associations that then drove me to spend time with certain videos from Gaza, rather

than an external "theory." These videos are hard to watch, so I haven't reproduced them. I direct you to them via QR codes or you can see them at an online archive at toseeinthedark.net.

Revulsion to Revolution

That association became a global intifada, a global uprising, led by students and other young people, all part of the global majority. The social media intifada in support of Gaza created a palpable change in visual politics. When footage was first seen of Hamas's attacks from Gaza inside Israel on October 7th, there was a widespread mainstream consensus in the media and via opinion polls in support of Israel. For example, on October 13, 2023, a poll for NPR and PBS showed 65% wanted the US government to publicly support Israel.

Israel's response was so intensely and indiscriminately violent that Oxfam announced in January 2024 that casualties outpaced casualties from every official war this century, including those in Syria, Iraq, and Afghanistan.[52] Despite the continued chorus of official support, the global majority saw this violence for themselves via their social media. By March 27, 2024, a Gallup poll in the US showed that 55% now disapproved of Israel's military action, with only 36% in support.

In short, watching video and seeing photographs of the genocide in Gaza on social media changed first the opinion of students and young people, and later that of the majority. Video from Gaza distributed via platforms created the

most notable transformation of digital era visual activism to date.

It took time for those watching to turn their revulsion into action. It was most notable in higher education, where I have worked for decades, and where change is always slow.

I did not know the word "scholasticide" before. It means the systematic destruction of education. The first attack on a school in Gaza came on October 17, 2023. At the time of writing, the IDF have damaged or destroyed all twelve of Gaza's universities, as well as 90% of schools. Their monotonous claim to have fired only on alleged "targets" is belied by the numbers. The United Nations reported in April 2024 that 95 university professors had been killed in Gaza and at least 5,479 students. That's an entire university, dead.

It was no coincidence, then, that in April 2024, students at Columbia University in New York created a Gaza solidarity encampment. Within days, other encampments arose around the world from Johannesburg to Sydney, and all over Europe and the Americas. Despite almost instant eviction by police, encampments continued to pop up across the summer of 2024. There were 120 in the United States alone.

The encampments activated revulsion at the violence that had been seen. Each encampment associated their institutions with the attack on Gaza, demanding the necessary steps of disclosure and divestment. It was a move from mourning to militancy, to borrow ACT UP's slogan in the face of the 1980s AIDS pandemic.[53] More exactly, as

Jill Casid puts it, in this context mourning is militancy, because it is so stringently forbidden.[54]

The outcome of this revulsion, an activation of the visible in the face of what has been seen, is literally revolution, a turning away from militarized violence and surveillance toward new forms of communal association. The commune.

Checkpoints

Ending the optical regime of settler-colonialism means making its ways of seeing and forming time-space visible. Because Palestine is the world, the paradigm institution of the "racializing surveillance"[55] of present-day racial patriarchal capitalism is now the checkpoint. The checkpoint is the hybrid physical and digital infrastructure of supremacy. The regime of saturation surveillance created by the plethora of checkpoints in Palestine both expresses the dominance of the settlers and ensures its continuation.

As a surveillance system, the checkpoint combines automated digital and optical surveillance with physical barricades and human surveillance in a distributed and variable network. Its surveillance regime is at once arbitrary, bureaucratic, massively material, and intensely violent.[56]

As Palestinian scholar Helga Tawil-Souri explains, "Checkpoints are first and foremost extensions of the Judaization, militarization, and fragmentation of Palestinian land, a physical manifestation of the territorial project of Zionist expansion."[57] The checkpoint breaks up space, fragments everything that might be understood as

"Palestine," and controls Palestinian populations by eliminating and containing those understood to be "dangerous." It operates by refusing passage to anyone about whom there is any suspicion whatever, whether detected by camera, database, or human perception.

This regime of saturation surveillance is designed to eliminate any Palestinian way of seeing. As visual theorists Nassar, Sheehi, and Tamari put it: "To understand the Palestinians themselves as subjects of their own visual field is to see an indigenous visual understanding (or visuality)."[58] That is not permissible in the settler-colonial way of seeing. The collapse of the presumed total success of this colonial surveillance was a key element in the shock caused by October 7th.

An entire range of checkpoints has been developed since the first Intifada, giving physical expression to the total surveillance regime. Highly fortified checkpoints operate between the occupied territories and what Palestinians call Palestine '48, meaning the land that was Palestine in 1948 and is now the state of Israel.

Most checkpoints operate within the territories, breaking even "Palestinian" areas into segregated zones. In 2017, there were 98 checkpoints within the West Bank. These are supplemented with over 300 temporary and unannounced "flying checkpoints" each month.[59] This hybrid system means that a person can never be sure if there is or is not a checkpoint on their route, or whether they will pass a given checkpoint.

Barbed wire and concrete blocks are used to restrict movement of people, animals, and vehicles as they approach. Electronic turnstiles ensure only one person at a time can pass. Sometimes, the turnstile leads to a closed room, where the traveler assumes they are being watched, before being allowed (or not) to exit. In the Shahuda Street checkpoint in Hebron, I saw IDF soldiers detain a young Palestinian woman in this closed room, simply to cause her to panic and become upset.

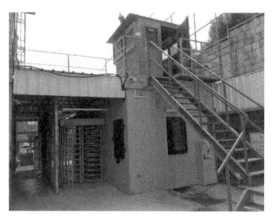

Fig. 1 Shahuda Street checkpoint, Hebron.

Checkpoint surveillance comes in multiple forms. Where there is a permanent barrier, there is often a watchtower and elevated platform. CCTV cameras are extensively used. Palestinians wishing to cross must have both an identification card and active biometric travel permit, both surrounded by a maze of obfuscatory and often changing bureaucracy.[60] For example, in East Jerusalem, obtaining a permanent residency card does not guarantee the right to live there. The production of anxiety and depression is integral to the check-

point regime which is as much psychological as it is physical.

The checkpoints cannot be evaded because Israel has also constructed a 16-meter high "separation wall" between much of Palestine '48 and the West Bank. On my 2016 visit, I was shown a space where there was a gap in a much less intimidating fence that appeared to offer a way through. My guide told me that it was always watched by Israeli snipers and so to cross here would be fatal. Sometimes an entire checkpoint is closed, perhaps randomly, or as a "punishment" for an act of resistance. That event might have nothing to do with the location of the checkpoint. Checkpoints from the West Bank into Palestine '48 were closed after October 7th.

There are only three checkpoints into Gaza itself, which are all highly fortified. All were closed after October 7th, making the supply of food and other essentials extremely precarious. Gaza has long been defined as the world's largest open-air prison, while Israel is certainly a carceral state. Shut off from the outside world, Gaza is both invisible and hypervisible. Its entire perimeter is enclosed within a triple fence of barbed wire, razor wire, and chain-link fencing.

Since the beginning of the student-led global intifada, checkpoints have become a feature of campus life in the US. In my own institution, the NYPD were invited in to evict an encampment on April 22, 2024. Over 100 faculty, students, and staff were arrested, although no charges were ever brought. The next day a wooden fence was erected around a metal frame, supported by

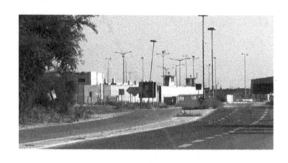

Fig. 2 Erez Checkpoint, Gaza, photographed
from a moving vehicle.

wooden buttresses. Three doors in the fence were staffed by security guards 24/7, who inspected IDs and checked names because the university had declared some students persona non grata, unwelcome people.

This new wall fenced off the business school, creating an unintentional resonance with the history of Wall Street itself. The name stems from the presence of a physical wall, built by enslaved Africans to keep out Indigenous people—and also to contain the enslaved. When the Berlin Wall fell in 1989, it felt as if an era had come to an end.[61] Today, walls and checkpoints are both the visible form of state and institutional dominance and the centerpiece of far-right politics.

The non-lethal checkpoints at universities are not the same as a checkpoint in Palestine but they assert the same principle that security overrules human rights. At the same time, they show that settler colonialism, as most visible in Palestine, shapes the world that everyone lives in to differing degrees.

To See In the Dark

Nicholas Mirzoeff

Fig. 3 Checkpoint on the NYU campus at
Gould Plaza.

Digital Surveillance

In its attacks on Gaza since October 7th, the IDF
has extended its digital surveillance regime. To
do so, it has used small drones, technically known
as "quadcopters" because they use four rotors.
These devices start with cheap Chinese-made DJI
drones that can be bought online. Next up are US
Lemurs that can be instructed to break windows
and offer 4K video to their operator. Top of the
line is the Israeli Xtend that uses AI and VR
headsets to create an immersive environment.
According to the company's management, Xtend
has deployed grenades and detonated mines by
dropping things on them.

Just as the Uncrewed Aerial Vehicle (UAV)
made its battlefield debut with the IDF invasion of
Lebanon in 1982, the attack on Gaza is opening
a new era of distributed and swarming drones.
There were reports in April 2024 from Nuseirat

refugee camp that Israeli quadcopters played sounds of women and children in distress to draw men out of their shelters at night.[62]

Drones are not yet autonomous. The IDF make decisions based on the suspicious logic of the checkpoint. As a result, in December 2023 the IDF killed three Israeli hostages who spoke Hebrew and were waving a white flag because their suspicion outweighed the appearance of surrender. In previous attacks, the IDF had used a system of "target cards" to identify targets as well as potential "collateral damage," meaning civilian casualties. It now deploys facial recognition and artificial intelligence to scan surveillance footage and identify "wanted" persons.

Two AI programs called "Lavender" and "Gospel" target people and buildings respectively, using a dataset that produced very high numbers of such "targets" with an expected error rate of 10%. As many as 37,000 people were identified in this way with human commanders signing off in all cases when the person was identified as male.[63] In a cynically named program called "Daddy's home," suspects were followed until they reached their home and were then bombed. These programs account in part for the spectacular level of casualties: "during the first weeks, for every junior Hamas operative that Lavender marked, it was permissible to kill up to 15 or 20 civilians."[64]

According to the *New York Times*, Israeli software company Corsight used Google photos to create a database of these individuals.[65] Just as with the checkpoints, the databases assume any person can be a threat. One result was the unjustified deten-

tion and violent interrogation of Palestinian poet Mosab Abu Toha, which he later documented in the *New Yorker*.[66]

The *New York Times* further revealed that Palestinians detained at Sde Teiman camp were routinely subjected to electric shocks and rectal penetration with metal sticks and electrified tools. Guards enforced nudity, blindfolds, stress positions, and played deafening music in the manner of the notorious 2004 US interrogations at Abu Ghraib in Iraq.[67] Even when civilians at Sde Teiman—a nurse, an ambulance driver, a law student—had no information, it was treated as evidence of guilt. Thirty-five people died.[68]

As if to emphasize that surveillance is now hybrid, the whole of Gaza is to be still more permanently incarcerated when and if the "hot" operation is declared over and Israel reverts to its long slow genocide in Palestine. Israeli human rights organization B'Tselem have documented that in early November 2023 Israel began constructing a kilometer wide "security zone" in Gaza inside the entire 60-kilometer border, where no Palestinian will be allowed to set foot, all monitored by surveillance devices.[69]

This new construction is the Berlin Wall on steroids. The 1961 wall separating East and West Berlin was supplemented in 1962 with a second barrier about 100 meters into the DDR. A closely watched strip of sand that came to be known as the "death strip" was inserted in between the two. Israel's new surveillance zone will be ten times larger.

For the IDF, anyone they kill is a "target" or "terrorist" by definition: because they were killed, they were targets, or willfully close to a target. Viewers of these events outside Palestine, engaging with videos on their devices, instead chose to see people as people not data.

To use the formula of French philosopher Jacques Rancière, "Politics, before all else, is an intervention in the visible and the sayable."[70] The claim to determine that relationship is what he calls "police." The police determine who is a terrorist. My grandmother, for example. After a year of genocide, I think politics is now the meeting of the visible and the unspeakable. Unspeakable in that what is visible is so awful as to be beyond ordinary words. Unspeakable in that what is visible is forbidden to be said. So, it must be spoken in extraordinary ways.

What has been sayable about the unspeakable? It has been poets who have found ways to make language do what it should not have to do. Writing about the Holocaust, the poet Anne Michaels notes "the power of language to restore."[71] That restoration is care, solidarity, and love.

There is no writing that can connect the colonizer and the colonized in some form of common discourse. My own equivocations on this score are part of my apparatus of dissociation. Undoing dissociation means ending this ambiguous speaking (the "vocation" in equivocation), even though it feels more "academic" to do so.

Indeed, the uses of language have become a matter of everyday politics. There have been loud claims from supporters of Israel that the slogan "from the river to the sea" can only imply exterminating all Jews between the Jordan river and the Mediterranean. At one level, this is the familiar and foundational operation of white supremacy, to assert that the dominated would necessarily act according to the present mode of domination were they to gain power. More specifically, it polices language so that the phrase "Palestine will be free" must mean "free of Jews," as if it was Nazi thinking.

Historian Maha Nassar points out "the call for a free Palestine 'from the river to the sea' gained traction in the 1960s. It was part of a larger call to see a secular democratic state established in all of historic Palestine."[72] Free simply meant "free," in its widely used senses of self-determination and participation in democracy. Since October 7th, those using the phrase outside Palestine, especially in the US and Germany, have nonetheless lost jobs, been subject to disciplinary measures, or even faced criminal charges.

Visual symbols are equally subjected to this policing. In June 2024, upside-down red triangles were painted on the residences of managers of the Brooklyn Museum, New York, after police had violently arrested protestors outside the museum. These triangles were at once said to refer to Nazi concentration camp badges. However, the red triangle in those camps designated Communist or other left-wing prisoners, not Jews.

The red triangle today has several meanings. It alludes to the red triangle in the Palestinian national flag. An upside-down red triangle has also been used since October 7 in Hamas and Islamic Jihad videos to indicate targets in blurry action footage. From there, it has become a symbol of resistance. The IDF in turn appropriated this triangle to show its greater firepower in its own videos.

In the era of the meme, this is how symbols travel. Such disputes always exceed their original frame. There have been allegations that the Delta Airlines logo, which involves a red triangle, is a covert antisemitic message. The goal is to sustain the view that antisemitism is now on the rise, rather than make a serious point about Delta Airlines.

Palestine Everywhere

The establishment of the first Gaza solidarity encampment at Columbia University coincided with a flurry of pro-Palestine protest at the opening of the Venice Biennale on April 17, 2024. One of the most visible phenomena of global capitalism has been the formation of a spectacular "artworld," perpetually in motion like capital itself, from art fair to Biennale and museum opening.

Much of the art sold in this world is machinic, produced by fabricators as a form of high-end interior decorating. Damien Hirst's dot paintings are churned out to meet the needs of investors with large lofts, just as Jeff Koons's statues sit well in the grounds of billionaires' mansions. Other

work is investment grade, a way to store liquidity in duty-free storage, in case of sudden need.[73]

In an unexpected twist, the art that was valued as art rather than as furnishing came to take on ever more critical positions. Many artists believe that their work now is thinking and talking together, making political protests, and creating alternative ways of living, rather than making material objects.

Brazilian curator Adriano Pedrosa selected the Venice Biennale's slogan "Foreigners Everywhere" from a series by one such artist, Claire Fontaine. Claire Fontaine is a made-up person who came into being in 2004, using the name of a popular French stationery to make a pun on Marcel Duchamp's *Fountain* (1917). The slogan "Foreigners Everywhere" was itself appropriated from a radical zine in Turin, Italy. It was a calculated provocation to xenophobia everywhere and to Italy's far-right government, in particular.

The Biennale's opening, normally a series of extravagant parties, was marked instead by

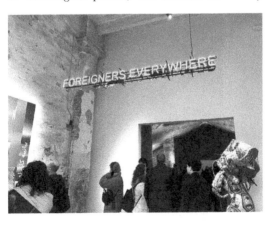

Fig. 4 Claire Fontaine, *Foreigners Everywhere* (2024).

protests around Gaza. These actions were themselves artworks, ones without price. On the first day of previews, artists and others forced the Israel pavilion to close. The fact that Israel's pavilion is adjacent to the US made the topography of this artworld all too clear.

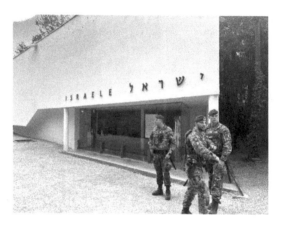

Fig. 5 The Israel Pavilion,
Venice Biennale, 2024.

Inside the Biennale space, behind checkpoints protected by QR code entry, reinforced with required photo ID and armed police, artists who supported the boycott of Israel marked their work accordingly. US Black artists and critics created a rose petal memorial, with each petal carrying the name of a woman killed in Gaza—even this little memorial soon attracted Italian police and those in attendance were required to disperse.

Palestinian artists and their allies organized evocative actions. *The Freedom Boat* docked at the entrance to the Biennale and provided a key intersection with the small boats crisis of migrants and refugees. Volume 1 of the *Gaza Reader*, comprised

Fig. 6 Rose petal memorial for women killed
in Gaza, Venice, April 2024.

of poetry from and about Gaza, was printed and
distributed for free.[74] Readings were held each day,
providing a time and space to gather and reflect.

Poetry has been so important both within Gaza
and in the global intifada because it actively works
to reconnect the visible and the unspeakable. It
crosses the border between inside and outside that
Israel has worked so hard to make impermeable.
It finds ways to make the unspeakable sayable,
so necessary in these horrendous circumstances.
To write poetry amid violence is always resis-
tance. Palestinian poetry today gives verbal form
to what has been made visible in the dark since
October 7th.

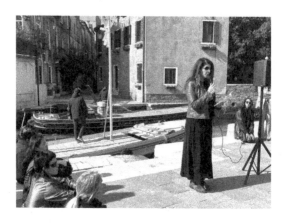

Fig. 7 *The Freedom Boat* moored in Venice
with a poetry reading in progress.

Video In the Dark

To close, let's consider two videos that try to
see in the dark. In a side alley near the Gallerie
dell'Accademia, a small but powerful group show
called "South West Bank" centered Palestine and
the work of the Dar Jacir center in Bethlehem.
Artists Emily Jacir and Andrea de Siena created
the short video *Paesaggio Umano* (2022) from a
series of dance and movement workshops at Dar
Jacir. In one sequence, figures are seen lying on
the ground. One struggles to rise, clutching her
throat. As she gains her ground, others also rise,
hands on throats, until they move into a collec-
tive dance that allows the final prone figure to rise.
It reversed the Black Lives Matter slogan "I can't
breathe," the last words of Eric Garner, killed
by police in New York in 2014, and repeated by
George Floyd in 2020. The performance enacted
the embodied refusal to be expunged, asserting
that existence is resistance.

The other video was off-site in an exhibit called "Nebula," made by the Palestinian artists Basel Abbas and Ruanne Abou-Rahme, whose work recurs throughout this pamphlet. Their multi-room multi-media installation, *Until we became fire and fire us*, was the most recent installment of their engagement with "past and present forms of dispossession and erasure in Palestine," to quote the exhibit brochure. "The work rekindles the traces of alienated existences and transforms them into an intergenerational means for spiritual and bodily reconnection."[75] I hope to contribute to that process here, as an anti-Zionist Jew in solidarity with Palestine.

One screen in this installation haunted me. It shows an elegant young man at sunset, seated on a cairn of rubble amid the ruins of a building. Was this his home? After a while he gets up and walks into the surrounding desert. A text reads: "My friend hides in Jerusalem. A fugitive to stay free. He can't walk the streets in case he gets asked for his ID and gets dragged from prison to prison to prison to prison" (punctuation and capital letters added for clarity). The young man must remain a fugitive to stay free. His biometric ID could lead to his imprisonment for being out of place. He wanders among the rubble, venturing out at twilight to see in the dark. Yet, for now, he is free.

To See In the Dark

To see in the dark is to activate the visible against the dominant white settler-colonial way of seeing. The "dark" is the space outside the narrow purview of white sight as delineated in single point perspective and other visual technology, epitomized now by the uncrewed aerial vehicle, or drone. It is not literally dark, although the night has often been a resource for the colonized and the enslaved. It is a looking with both eyes. It is always in relation, always different, always deferring to others. Because it is not the sight of a single person but a collective and collaborative process, seeing in the dark has resilience and love whose older name is solidarity.[76] I do not see in the dark, we do.

White Sight

To see in the dark does not create a binary with "light." It contrasts rather with "white sight," a colonial technology that creates a visible white reality.[77] This "reality" is real only insofar as it conforms to the desire of the colonist. When it does not, violence returns matters to the colonist's desired condition. "White" here is a hierarchical relation, not (just) a measure of skin tone. In the slave law that regulated the plantation, "whiter" persons had dominion over the enslaved. In

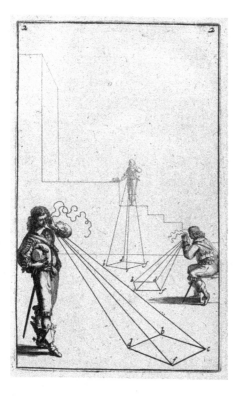

Fig. 8 Abraham Bosse, *Perspective* (1648).

Israel's Jewish supremacy today, enshrined in its
Basic Law, Mizrahi Jews from the Middle East,
North Africa, and Central Asia have dominion
over all Palestinians and other non-Jewish persons.

In 1648, the year in which the Treaty of West-
phalia defined the Western colonial nation-state,
the French engraver Abraham Bosse visualized
the relation between the state and seeing as the
practice of armed white soldiers. Always seeing
from above, this white sight erases all human
and non-human life from what it surveys so that
it can claim what remains as *terra nullius*, nothing
land—or to put it another way, "a land without a

people." US English calls the militarized possession of calculable space "real estate"—the "real" here meaning white reality.

Jump cut to 1982, the year of Israel's invasion of Lebanon, in which a variety of new weapons were tried out, including a prototype remotely piloted vehicle, or what has become known as the drone. In a line drawing published that year as an illustration in *Aviation Week*, an arms trade technical journal, a drone can be seen projecting pyramidical lines in front of it, casting rectangular white boxes on the ground, just like the colonial soldiers in 1648 (because it's a military-industrial complex journal, the cost of reproduction is absurd, so I cannot reproduce it here).[78] As with the soldiers, the white boxes show nothing within.

With the vehicle flying at a height of 1,000 meters, it could "see" three boxes, comprising 19.3 square miles out of the 115.8 sq. miles potentially visible in a circle, or 16.6% of what there is to see. Its angle of vision was around 25 degrees of 360, just 7%. By comparison, a human's "central vision includes an inner 30 degrees of vision, and a peripheral visual field, which extends 100 degrees laterally, 60 degrees medially, 60 degrees upward, and 75 degrees downward."[79] Using just a fragment of the human visual field, white sight militarizes this segment as its "reality."

White Sight in Gaza

The difference between perspective and the drone is that a screen mediates the soldier and the device. The drone "sees" and transmits what it

perceives to its operators, sitting safely away from the battlefield. Using joysticks designed for video games, operators can fly multiple drones and take decisions about whether and when to fire their weapons. From 2009 on, Israel has used drones in Gaza for attack operations and for surveillance.[80]

Operators call the space the drone can see the "kill box." There is a US Army manual describing how to operate the kill box, requiring forms to be filled out after the event. Nonetheless, kill box means what it says: anything that can be seen (except in the small, designated No-Fire Areas) can be killed.

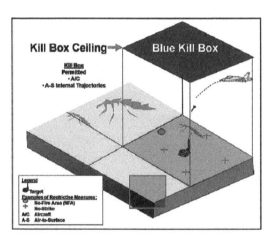

Fig. 9 *US Field Manual 3-09.34* "Blue Kill Box"
(Public Domain).

The aerial assault by planes and by drones in Gaza has condensed this history of white sight as a colonial technology. In its scorched-earth operations, the IDF has defined all of Gaza as a kill box. Gaza, seen by Israel as *terra nullius*, is available to be erased by IDF soldiers. Acting in this frame,

Israel has bulldozed refugee camps in the West Bank, bombed Beirut, and assassinated Iranian leaders.

After October 7th, Gaza was at first divided into the north, where everything was a target; and the south, where no one was safe, but not everything was shot at. Then it became clear that the south was equally targeted. The IDF keeps dropping leaflets requiring surviving civilians to uproot over and again to different areas. Aid vehicles were "accidentally" targeted across the kill box, reducing available food and medical supplies still further. IDF attacked safe areas repeatedly, with heavy civilian casualties, endlessly "justified" by the claim that Hamas operatives may have been present. All Gaza is a kill box.

To take just one example, in May 2024, at least 35 people were killed in a designated safe area in Rafah. The resulting video showing a bereft man holding up the body of a headless infant against a wall of flame in the dark will not be forgotten by those who have seen it. Anyone watching felt as if they could be in that kill box.

Seeing Like Drones

By 2023, all of us who watch screens had already been trained to see like drones. Drone footage appears in all TV dramas these days, not to mention advertising, especially for cars. The drone viewpoint is distinct from the aerial camera because it sees directly above what it is looking at, making people hard to distinguish, while vehicles,

roads and buildings appear in sharp outline. It is the ideal way to bomb.

In the 1991 Gulf War, film shared from so-called "smart" bombs showing the bombs flying toward their targets caused a sense of cultural rupture, not least because the film stopped when the bomb exploded. This narrative closure gave a false sense of precision. Later it became clear these weapons were no more accurate than other bombs. The difference was that we could see them causing damage. Today, such bomb footage, marked by the inevitable column of smoke, causes no shock, and is treated as part of "normal" operations.

There have been notable disruptions to this top-down view of the world since October 7th. In the initial assault Hamas used cheap commercial drones to attack Israeli watchtowers and video cameras, reversing the given dynamic of colonial surveillance. Video taken by Hamas operatives during the October 7th attacks, later circulated by the IDF, was received in the pro-Israel mainstream as far more shocking than, say, the dropping of massive 2,000lb bombs on Jabalia refugee camp, killing and wounding hundreds of civilians. On October 31, 2023, Wolf Blitzer interviewed Lt. Col. Richard Hecht of the IDF on CNN after the bombing of Jabalia, allegedly to kill a Hamas commander. Blitzer pressed him to confirm that the attack went ahead even though they knew the area was full of refugees and, to his surprise, Hecht did so.[81]

After 30 years of watching smart bombs, the direct sight of armed violence toward specific individuals still shocks in a way that mass military

action does not. So convinced of the power of this footage is the Israeli regime that they showed it to Western government officials immediately after October 7th. The shaken response of US Secretary of State Anthony Blinken suggested that the tactic had worked. By May 2024, it had worn off. When the governments of Spain, Norway, and Ireland formally recognized the Palestinian state, joining around 140 mostly non-Western nations, the Israeli government ordered their ambassadors to watch again video taken on October 7th. There was no change in their position.

Seeing In the Dark

To see in the dark is to see outside the kill box and outside the narrow segment of available vision commandeered by white sight. Seeing in the dark is the way of seeing of the watched, not the watchers, in those moments outside and beyond surveillance. It is in relation with what Black studies theorist Simone Browne calls "dark sousveillance," the monitoring of the watchers by those designated Black.[82] Seeing in the dark is the practice of solidarity, the means by which to see how colonialism is practiced.

In Anna Burns' novel *Milkman* (2018) about Northern Ireland during The Troubles—although the location is never named—the narrator describes how:

> where I lived . . . the whole place always seemed to be in the dark. It was as if the electric lights were turned off, always turned off, even though

dusk was over so they should have been turned on yet nobody was turning them on and nobody noticed either, that they weren't on. All this, too, seemed normality.[83]

The colonizer, whether in Ireland or Palestine, renders the dark as the only available way to see.

Seeing in the dark is also the awareness that something is very wrong, without relying on the simple binary of good and evil. Israeli journalist Gideon Levy, writing for the newspaper *Ha'aretz*, drew this distinction in relation to the violence of 2024: "It's so much easier to put everything on Netanyahu, because then you feel so good about yourself and Netanyahu is the darkness. But the darkness is everywhere."[84] For anti-Zionist Jews, to see in the dark is all there is.

In 2022, New York's Vera List Center for Art and Politics had engaged in a set of "Studies into Darkness." As the Center's website put it: "'Darkness' here holds the promise of complexity, discovery and, in [artist, filmmaker, and activist Amar] Kanwar's words, 'visions from within the depths.'" To see in the dark is a seeing in depth and with complexity.

It follows that the dark is not a synonym for evil. As revolutionary thinker Frantz Fanon recognized in the first wave of formal decolonization, "the colonial world is a Manichaean world . . . the colonist turns the colonized into a kind of quintessence of evil."[85] The Manichaeans were a religious sect, founded in the third century CE, who believed in the material existence of evil, which had to be fought directly. While the religion

43

was treated as a heresy by Christianity, popular culture today is extensively Manichaean—taking evil as an active force in the lived world—as seen in countless films, notably *The Exorcist* (1973), and subsequent TV series like *The Outsider* (2000), or *Law and Order: SVU* (1999–present).

For Fanon, colonial Manichaeanism "dehumanizes" and renders the colonized into "the state of an animal."[86] Just so, Israeli defense minister Yoav Gallant called those living in Gaza "human animals" in the immediate aftermath of October 7th to justify the IDF use of unrestrained violence. Fanon had foreseen that colonial Manichaeanism produces a "spiral of domination, exploitation and looting."[87] In short, the violence of classifying people as "animals" produces an intense and violent reaction.

Seeing with Both Eyes

An open heart has two ears, two eyes.
One set for breath, one set for blood.
—Fady Joudah, *[…]*[88]

Seeing in the dark is a seeing with both eyes, distinct from the one-point, one-eyed, one-lens machine vision of white sight. In the months after October 7th, my right eye was crying constantly. Drops, compresses, flushes—nothing worked. The left eye contradicted all diagnosis by staying clear. That's where we are now with the resistance to white sight. One eye in constant grief and mourning, the other trying to focus on such possibilities as still exist. One eye sees how the sol-

idarity movement continues to make gains with its encampments, protests, and refusal. The other mourns the ongoing catastrophe of the Israeli punitive expedition in Gaza, which it sees as part of the far-right surge of white supremacy from Argentina to the Netherlands and the US.

The right eye tells me that there's no clear-eyed seeing of this violence as it unfolds, which is not the same as saying it cannot be documented or accounted for. Seeing in the dark is not crisp and clear. It is for the present a seeing through tears, a crepuscular ambivalence.

It enables me to see how the violence against civilians of the October 7th attacks both can be understood as an outcome of colonialism and be mourned at the personal level. I can be shocked by video of on the ground shooting and by video of remote targeted bombing. I can express solidarity with the people of Gaza, while not being aligned with Hamas, even as I see how the IDF's actions will only reinforce Hamas's position. I can see that the call for Hamas to be exterminated could only be achieved by expelling or exterminating all the people of Gaza, just as certain figures on the Israeli far-right have said.

In this anticolonial way of seeing, it's possible to imagine Jews living in Palestine without Jewish supremacy, as they did before 1948. It's possible to imagine all the people now living there as part of a single political entity, whether a state, a confederation, or a post-state way of organizing social life. Most of all, it's possible to imagine Palestinian freedom.

Seeing in the dark is both the result of, and creates a category crisis in relation to, what I call "bare witness," a witnessing without the protection of the state or other institutions. Governments, universities, museums, and other components of state and civil society have cohered around the definition of antisemitism as any criticism whatever of the state of Israel, including the use of the word Zionism, or the term settler colonialism.

In his poem entitled "[...]," a name that can be read but not spoken, Palestinian-American poet Fady Joudah sets his reader this task across a line break:

To see

what isn't hard to see
in a world that doesn't.[89]

It is not hard to see but, like his title, it is not easy to say. To say what you see is now to put yourself at risk. To offer bare witness has cost people their jobs, lost them opportunities such as museum exhibitions or book prizes, and exposed them to scarring and scary harassment from the Internet. That is why such witness needs to be collective.

Collective bare witness outside Palestine has focused on materials available via social media rather than the established print and TV news formats. To the consternation of the pro-Israel lobby, its carceral visuality is no longer carrying all before it.

The persistent parallel to the 9/11 attacks drawn by Biden and Netanyahu resonated little with those born after it happened. The widespread solidarity for Palestine among Black activists and artists in Black Lives Matter awoke many of the young people who followed them to the issue.

The compulsory Israeli nationalism that has emerged since October 7th is an extension of post-2020 white nationalism because, as Alana Lentin points out, for certain white people, "opposition to antisemitism functions as a ballast against denouncements of racism."[90] In the US, anti-antisemitism forecloses opposition to anti-Black racism, for example.

The Smartphone Intifada

The global intifada was enabled by the smartphone. Smartphone adoption rate in the Middle East is now around 80%, the same level as the US and Europe. The young people who watched 17-year-old Darnella Frazier's video of the murder of George Floyd and were then told by Derek Chauvin's prosecutors to "believe what you saw," are now looking at videos and photos posted to Instagram and TikTok from Gaza and are again believing it.

Israel's blockade of Gaza required outside news agencies to retain "stringers" in Gaza, giving work and experience to local photojournalists and videographers. For example, 2015 Pulitzer Prize finalist photographer Wissam Nassar now has 1.7 million followers on Instagram. His fellow photographer Motaz Azaiza has 18 million. These

audiences are small by global media standards but by repeated sharing and other forms of "influence," to use social media's terminology, the results are disproportionate. Journalists in Gaza frame and shape their work by "international standards" so that "Western" audiences find it convincing.

By contrast, Israeli Rear Admiral Daniel Hagari, spokesperson for the IDF, did not convince. He operates in a TV news framework, speaking to camera in highly controlled circumstances to selected accredited journalists. He lost credibility when he claimed to US TV news that a small underground room in a hospital was Hamas's headquarters. Could this little room really threaten Israel? Or was it just what it seemed to be, a room in a hospital?

Former Israeli prime minister Ehud Barak casually admitted on CNN, to the astonishment of Christiane Amanpour, that these rooms were actually built by Israel. Those who read Arabic pointed out that the alleged list of hostages on the wall was a calendar.[91] Israelis call this *hasbara*, or propaganda, and the state has long believed that by sheer persistence it can make any situation be viewed its way.

Smartphones are not so amenable. They offer a different way of seeing than legacy media. Television operates a conventional "window on the world," in a manner consistent with cinema and the Western tradition of painting. The larger TVs get, the closer they become to cinema. In each format, the device, canvas, or apparatus seeks to become "invisible" as the viewer feels themselves to be looking through a window, or transparent

fourth wall, onto a scene in which they are not a participant.

Watching media, whether video or stills—some now define photographs as "still video"—on a phone is very different. It is intimate, not so much an extension of ourselves, as Marshall McLuhan famously defined media, as a mediation of who and what the "self" is or might be. The device is held in the hand close to the face, while sound is likely only audible to the user via headphones or earbuds.

Digital media does not fit the traditional framework of messages being sent from one person to another via media. Instead, it works as a form of "intercorporeality," meaning a "conception of the human body as being constituted by its corporeal relations and interactions with other human or animate bodies."[92] As framed in the work of French existentialist philosopher Maurice Merleau-Ponty, the intercorporeal is how people experience themselves and others simultaneously, as in a handshake in which I touch and am touched.

The smartphone is the prosthetic by which an equivalent but remote connection is now made. Video and photography seen via the smartphone both affects, and is affected by, the user, who is not a disembodied observer, like a drone, but an implicated and embodied presence. Perhaps it's even possible to use smart devices to allow and claim the right to look?

The smartphone is now as much part of the body as glasses, contact lenses, or a hearing aid. All of these devices supplement the physical body.

Only the hearing aid would be designated by most able-bodied people as an assistive device because to be unable to process sound remains a sign of failure to be fully human. By contrast vision aids, like glasses, are thought to make people look smart. The smartphone operationalizes the body as "smart" so that it can act within the twenty-first-century mediascape. Not to have a phone today is to be a less than fully operational human. Put another way, all phone users are in this sense "disabled," requiring the phone to be complete.

Why did Gaza create a sense of affiliation and solidarity when other catastrophes, like that in Syria or the migrant crisis, did not (or only briefly)? Colonial white sight was intensely fixed on Gaza for months following October 7th, whereas other crises have not had similar degrees of attention. As a result, whereas one bombing of a school or many civilian casualties might be written off as part of the vicissitudes of war, repeated instances no longer seemed coincidental.

This relatively long timespan, even if it is just a fraction of the 75-year-long occupation of Palestine, allowed people on the ground to get visual documentation onto platforms. Each coming into solidarity was an activation, mediated by seeing in the dark on a smartphone.

Sensitive Content

The first thing I have seen in the morning for this past year is the "sensitive content" logo on Instagram or other platforms.

Fig. 10 Sensitive content logo on Instagram.

Shrouded behind the newly allusive design, in which the eye seems to have had a bite taken out of it by platforms that gradually eat their own, lurks each day's news from Gaza. Each morning, I must click it away, like banishing a ghost. Then it reveals all its devastating results. Shattered bodies, dead children, starving children, apocalyptic cityscapes. Rubble of all kinds—moral, physical, political, visible.

Platforms regulate what may be seen and by whom. Deletion can take place in the form of removal of posts, "shadow banning" (a process in which only your followers can see your posts), or the demotion of the material by the algorithm. In these threads, I have nonetheless found reference to mass graves at Gaza hospitals, or the murder of doctors, which mainstream media skipped over, or labeled "unverified," but which I could see for myself. Palestinian writer Sarah Aziza has described her version of this experience:

In the mornings, as others stumble toward their coffee, I wake and gather news of the dead . . . I turn with loathing to social media. Watch, I tell myself, as thin men in sandaled feet rush into the frame. They begin pawing at the slabs of cement, rebar, brick. Shouts ricochet. The camera moves closer. My ears begin to ring. I long to click away. Watch. These are your people. I force my eyes to stay. Bear witness.[93]

When I watch similar content, I can and do feel a similar response, although Palestinians are not "my people." An association is created, undoing the denial and dissociation ("nothing to do with me" or "what can you do?") of decades. The question becomes what action is required when you and I become both bare witnesses and part of a new "we."

There are several layers of participation in this new collective assemblage formed by the move from dissociation to association. The first is ethical revulsion, a judgement that what is being seen is wrong. This distinction is not made in terms of international law or the much-trumpeted right of nations to self-defense. It sees each civilian death as wrong. It recognizes, first, that Palestinians are "levelly human" with everyone else, to quote the Combahee River Collective statement from 1977.[94]

In so doing, all racial hierarchy becomes seen for what it is—unethical and morally wrong. It's not as easy for white-identified people to make that step as it should be. The intensity with which some Jews have identified with Israel is also part

of their claim to be on the dominant side of racial hierarchy. I know that impulse, that desire to be seen as fully "white," as much as I repudiate it. I have to renew that work every day.

That ethical shift is itself a form of movement, from which other action may follow. Maybe even a social movement. Sharing what has been seen on your own feed is often the first step. Often sneered at, this sharing was not without risk of losing friends, of being labeled antisemitic, or even as a terrorist. It enabled many to see past the filters of mainstream media, which struggled both with the sheer violence of the material and the anxiety that they too would be called out as antisemitic.

From there, a person might choose to participate in a march, a rally, or a sit-in. To take one key example, on October 27, 2023, hundreds of Jewish Voice for Peace activists held a sit-in at Grand Central Station, New York, demanding a ceasefire using the slogans "Not In Our Name" and "Jews for Ceasefire."[95] On that day 21 of Israel's incursion into Gaza, there were already over 7,300 dead and 19,000 wounded. The event was well planned to create vivid photographs and videos that were widely circulated on both mainstream and social media platforms. The action helped undo the assumption that all calls for a ceasefire must be antisemitic. It resonated with past actions by ACT UP at the onset of the AIDS pandemic. And it helped persuade others who had hesitated to join a protest that it was acceptable or even necessary to do so.

These micro-encounters between viewers and visual media were repeated on a national and

international scale. Palestine protests before 2023 rarely attracted large numbers, except during Israel's attacks on Gaza in 2014 and 2018. The numbers attending marches and other actions in 2024 in the United States and United Kingdom were far larger and far more widespread. When college students began to protest in April 2024, it was not just at institutions like Columbia that have a long history of activism but places like USC that really do not.

The smartphone intifada was underway. Digital activism enabled in-person and "on the streets" protest. Posts from Gaza on social media platforms were directed as much at international viewers as the local community, given the collapse of Internet and cell service in the region. At first, they were not made visible to international users. A wave of posts on the platforms and resulting media articles began on October 16, 2023, highlighting complaints that Instagram, in particular, was not allowing posts concerning Palestine.[96] Human Rights Watch documented over 1,000 posts being removed in October and November 2023 in a manner they described as "systemic and global."[97]

There has been a constant black boxed struggle to keep Palestine visible, which has been surprisingly successful. What appears to have happened since is an uneven relaxation of this takedown on Instagram. Perhaps Meta was simply too greedy for the data and the opportunity to push ads to refuse these posts, even though individual items are still often removed. It has maintained Facebook, with its older audience, as a censori-

ous platform.[98] Consequently, people posting from Gaza often request users to download their materials and share them separately, fearing deletion by the platforms. These downloads have created a decentered vernacular archive of the war.

How to See Gaza?

How can we analyze this social media content from Gaza? As media scholars Rachel Kuo and Sarah Jackson have shown, analyzing Instagram can't be done in quantitative fashion, but "requires contextual visual analysis."[99]

The context here is unparalleled. It is what Ahmed Kabel calls the "'cidal swarm': genocide, spaciocide, sociocide, politicide, urbicide, economicide, epistemicide, historicide, memoricide, culturicide, linguicide, phenomenocide, ontocide, semanticide, educide, ecocide."[100] Each of these attempts at extermination has its own archive, which may or may not be accessible. It may have to be created, imagined, or collaboratively constructed.

Each commitment to watch what is so hard to watch was a labor of solidarity. After October 7th, I was at first reluctant to look at visual documentation from Gaza. In ways that are not necessarily "logical," but that I cannot deny, the violence unleashed by Israel resonated with my own histories of violence. Like it or not, those histories frame my way of seeing.

Following the war is at once care work and activist work. I follow a range of Palestinian activists and journalists from the region. There were

a variety of genres in these posts. Many depicted scenes showing violence toward women and children. There are repeated scenes of physical devastation. Many depicted personal injuries caused by modern high explosive. Others showed people mourning for lost loved ones. Equally, there are posts of resistance, sometimes just by sustaining everyday life with a visit to the beach or cooking.

Journalist Bisan Owda was nominated for an Emmy for her posts beginning, "This is Bisan from Gaza and I'm still alive." Her project echoed the artist On Kawara, who sent over 900 telegrams beginning in 1969, saying, "I am still alive." While On Kawara's work is in the Guggenheim, Bisan was denounced in the *New York Times* and other media outlets as a "terrorist" for an alleged appearance she made for the leftist Popular Front for the Liberation of Palestine in 2015.

There was also a specific archive showing young people being rescued from the rubble. When pushed as to why I had archived these, I realized it resonated with my own traumatic memories. Which is neither here nor there, except that it shows how there are layers of the personal and the political that even trained viewers do not "see" because they—all right, I—dissociate them.

On May 12, 2024, I saved a reel from my Instagram by Egyptian journalist Rahma Zein, although I didn't follow her then (QR code below). It shows a man cautiously excavating a child out of rubble by hand, only lightly protected with a rubber glove. Shot very close to the scene, it offers no "context," other than that implied by

the credentials of the posting journalist and the unending violence in Gaza. At first nothing can be seen but rubble, illuminated by a torch. But we can hear a child from beneath it, calling for their mother. The man excavating, who names himself as Fares Abu Hamza, calmly and gently reassures the child that she is coming, although we suspect she is dead. Fares removes a large block in the center of the frame. At this point, the child begins to become visible. She is lying on her back with her head concealed by a larger piece of rubble that he cannot move. His extraction of her from underneath it causes her to cry out in pain but finally she is revealed, head covered in blood but otherwise well and clearly going to survive.

The edited video is less than a minute long, but it feels like a feature length movie, such as *33* (2015, dir. Patricia Riggen) about the recovery of Chilean miners trapped underground. It makes me imagine the bombing that caused the entomb-

POST SHARED ON MAY 12
BY ZEIN_RAHMA

Fig. 11 Instagram post QR code Zein Rahma, May 12, 2024.

ment, the search to establish where survivors can be found who can be reached by hand, what it must have been like to be buried like that, the moment of freedom, and the realization of loss that must follow.

This video archive makes visible the extraction of human bodies from the rubble that colonial violence necessitates. The extraction of these bodies, alive or dead, is the human counterpoint to the colonial extraction of life and land.

Of all the shocks from Gaza, it is perhaps the repeated deaths of children in awful and upsetting ways that has been hardest to bear. On May 15, 2024, I saw a video reposted by photographer Wissam Nassar from Everyday Palestine, showing two small children who had been crushed in a building and died. Other than bruises and cuts, there is no catastrophic visible injury, but the absence of life is palpable.

I saw the photo posted by the poet Mosab Abu Toha, a finalist for the National Book Critics Circle

POST SHARED ON MAY 15
BY EVERYDAYPALESTINE

Fig. 12 Instagram post QR code Everyday Palestine, May 15, 2024.

Award for Poetry, on May 13, 2024. It shows an emergency medical worker holding a tiny baby, no more than a few days old, coated in the grey dust of rubble and with blood. It's not possible to be sure if they are alive but their fingers seem to be clinging to the gloved hand of the medic, who is holding an inch-thick dressing to their head, an action that would not be needed with a corpse. Like Fares, the care and gentleness that the worker shows redeems this otherwise traumatic picture.

POST SHARED ON MAY 13
BY MOSAB_ABUTOHA

Fig. 13 Instagram post
QR code Mosab Abu Toha,
May 13, 2024.

Not all the scenes are so unbearable. I encountered a photograph taken by Ali Jadallah, posted to Instagram on June 14, 2024. It has the aura of an Old Master painting, perhaps a Biblical scene. At center, a woman tentatively steps off a platform, perhaps the foundation of a house, carefully supported by a person behind her. A seated figure looks back, but we cannot tell at what because of the dust. Surrounded by a dust cloud, the woman's foot reaches cautiously into space,

evoking to my art historical memory depictions of the Virgin Mary, with her downcast modest gaze, often surrounded by mysterious billowing clouds of smoke. The figures in the photograph are all framed within this micro-rubble, in a way that art historians would call *sfumato*, literally "smoky," were it a painting. The trio are making their way off a mattress, perhaps having been attacked while sleeping. Amid all the violence and devastation, what resonates again is the care and the love.

POST SHARED ON JUNE 14
BY ALIJADALLAH66

Fig. 14 Instagram post
QR code Ali Jadallah, June
14, 2024.

I found witnessing these events transformative, even if it took months to frame in coherent words how and why. This seeing enabled me to make personal and political connections between histories of violence. As Arpan Roy points out: "In Arabic, shāhid meaning 'witness,' is closely related to shahīd, meaning 'martyr.'" He continues:

If we are to take this etymology of shahid seriously, that the witness and the martyr are two

layers of the same semantic topography, then we must also assume a greater responsibility in witnessing the death and destruction in Gaza. By watching the videos, the witness is transformed, breaking through the boundaries of what in political activism du jour is called "allyship"—a tactical alliance that assumes a separation between two self-constituting subjects or worlds. But for the shahid, there is no separation as such.[101]

Roy articulates in different terms the distinction I am drawing here between white sight and seeing in the dark. To see in the dark is to witness in intercorporeal ways what is happening, bringing the seer's world together with that of the seen.

There are profound differences in witnessing what is happening in Gaza on the ground or via digitized screens. Nonetheless, as I and so many others have experienced, there has been a felt and embodied transformation that results from the mediated intimacy with such violence. Dissociation becomes association. The overarching visual activist project is now to turn that revulsion into revolution.

Rubble

The material condition that grounds the effort to see in the dark is what I will call "rubble." As John Berger observed over 20 years ago, "Everywhere one goes in Palestine—even in rural areas—one finds oneself amongst rubble."[102] Rubble has been a significant part of urban existence since 1945. I grew up in a London still dotted with rubble-strewn bomb sites. It was still an exception. Today, from Aleppo to Detroit and Gaza, the present condition of urban counterinsurgency is rubble everywhere.

In the first months of the Second World War, Walter Benjamin envisaged history as a "single catastrophe, which unceasingly piles rubble on top of rubble."[103] Rubble surrounds me now, like Nagg in his bin, in Samuel Beckett's Nakba-era play *Endgame* (1957). Nagg realizes "our sight has failed." Hasn't it just? The characters talk of a painter gone mad: "all he had seen was ashes." Pause. "Nearly finished." Benjamin's and Beckett's rubble framed the Nakba. In Gaza today, almost all there is to see is ashes, dust, and rubble. And yet, poet Mahmoud Darwish tells us, it is in that rubble that we must search "for light, for poetry."[104]

Rubble is an anomaly. It belongs to the past, in which it was once whole; the present in which it is what it is; and the future when it will have been cleared away. Rubble is the trace of death

and dying. This is not about ghosts, that's another story. The sight of rubble is the sight of death. The rubble in Gaza contains the mortal remains of an unknown number of people, estimated around 10,000 by Save the Children in June 2024, unreachable by the limited means of excavation available.

Rubble is material. The UN estimated in March 2024 that the IDF had created 39 million tons of rubble in Gaza since October 2023, which will take 15 years to remove. It is three times the amount of rubble left in Berlin at the end of World War II. That being the case, it will be at least 15 years before it will be possible to imagine seeing beyond the "dark."

Removal is not simple: "For each square metre in the Gaza Strip, there is now over 107 kg of debris, which may contain UXO [unexploded ordinance], hazardous substances and human remains."[105] To put it another way, when Israel attacked Gaza in 2008, in what they called Operation Cast Lead, the devastation was such that war crimes indictments were made. The rubble produced then amounted to "only" 600,000 tons, less than 2% of what has been made since October 7th.

There have been ways of seeing with rubble before, such as Berlin's "rubble films" made in the city after Allied bombing in 1944, which could be thought alongside W. G. Sebald's *On The Natural History of Destruction* (1999). More recent conflicts have created new approaches. In the Syrian crisis, film collective Abou Nadarra used social media and streaming platforms like Vimeo to advance

their claim to "a more just right to the image." Ukrainian photographer Yevgenia Belorusets imagined the photograph "forming memories," rather than depicting them, understanding "the deep penetration of traumatic historical events into the fantasies and experiences of everyday life."[106] While recognizing such precedents, this is still a new moment in quality and quantity.

Berger saw in Palestine, "the rubble of words—the rubble of words that house nothing anymore, whose sense has been destroyed . . . There is the rubble too of sober and principled words which are being ignored."[107] The peace accords. The humanitarian statements. The calls, letters, and statements from so many that have amounted to so little.

In among that rubble now is the rubble of "images," meaning both their sheer quantity and the questioning of the "reality" in data visualization. A guess-timated 1.93 trillion photographs were made in 2023. If you took one photo per second, it would take over 30,000 years to take one trillion. 94% of these were taken using smart phones that are now image-sharing devices first and foremost. Around 14 billion photos are shared every day in 2024.[108] As for video, there were 500 hours of video uploaded to YouTube every minute in 2022—the most recent figures available. 625 million videos were watched on TikTok every minute in 2024. According to "global data and business intelligence platform" Statista, Instagram had 2 billion monthly users in 2024, with 1.5 billion on TikTok. Over 50% of the 170 million US Instagram users are under 35.

When digital photography first emerged, critics feared it would undermine the "indexical" value of the resulting images, meaning whether they accurately depicted external reality. Instead, there are selective accusations that specific imagery is fake, or that entire branches of the media are fake. Behind such calls, there is all too often an insistence that reality is white reality, the consensus created by militarized colonial white sight.

The young global majority sees a different reality on their devices—rubble.

Rubble of Seeing

Let's track this rubble of seeing back. Since 1972, the phrase "ways of seeing" has been associated with John Berger. His immensely successful book of that name was created as the companion to a BBC TV series. Concerned with European painting for the most part, Berger's book contains nothing about Palestine, very little about colonialism and just a few references to slavery. *Ways of Seeing* has become a canonical, almost sacred, text. Berger's later anti-imperialism, anti-Zionism and his emphasis on the "undefeated despair" in Palestine and in its art and poetry have, by comparison, been ignored. You can't have one without the other.

Beginning with the Second Intifada (2000), the Palestinian uprising against Israeli colonial rule, Berger became deeply invested in Palestine solidarity. Most likely it was his friend, the photographer Jean Mohr (1925–2018), who got Berger thinking about Palestine. A Swiss child of anti-

fascist German refugees, Mohr had worked in Palestine from 1949 on with the International Committee of the Red Cross (ICRC).

A previously unpublished 1950 photo I found by Mohr in the ICRC archive shows two young people closely studying a book, possibly a textbook. The setting is an ICRC school at a camp in Hebron. It's an evocative scene. A certain detachment allows the viewer to engage with the young people. Only then do you notice two adults off to the left watching the photograph being taken and others walking with a donkey up the stony slope. Someone has arranged the stones to mark out fields or living spaces, a labor beyond words. This rubble made life possible. Between the ropes of the tent, one can see vines protected from the winter cold and a few trees, perhaps marking a spring or water hole.

Viewed today, this photograph reminds me of the reading groups arranged during the Great

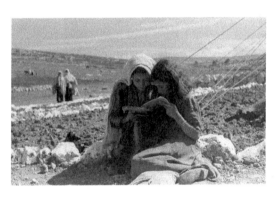

Fig. 15 Jean Mohr, "Hebron. Most Palestinian refugees live in tents. The ICRC sets up the first schools" (1950). Photo: International Committee of the Red Cross (public domain).

March of Return in 2018 between Gaza City and the border fence with Israel, as well as the opening scene of a young girl reading in the film *Farha* (2021, dir. Darin J. Sallam). Annexed by Israel in 1967, Hebron is now surrounded by illegal Jewish settlements, such as Kiryat Arba, while much of the rest of the land is designated for military use only (Area C) or annexed by the state. Checkpoints are everywhere. Mohr's powerful scene is unimaginable today.

In 1983 Berger introduced Mohr to Palestinian literary critic Edward Said at a conference in Geneva. The event was organized by the United Nations, which allowed an exhibit of Mohr's photographs on the bizarre condition that there be no captions identifying the subjects as Palestinian. The lively discussion as to how best to respond resulted in the now-classic book *After the Last Sky* (1986), in which Said's evocative description of Palestinian life and identity runs alongside Mohr's photos, rather than engaging with them systematically.

Video

Berger first wrote about Palestine in a short 2003 diary piece for the *London Review of Books*. He reported from Ramallah, using the word "nakba" in the first sentence. Berger described how, confronted with the many posters depicting the martyrs of the Second Intifada, he set out to make a drawing in the Palestinian village Ein Qiniya as a memorial to the painter Abdelhamid

Kharti, tortured and killed while volunteering for a medical emergency team.

He understood that the occupation intended "to destroy the indigenous population's sense of temporal and spatial continuity."[109] What is the way of seeing where space is not continuous?

As was his custom, Berger listened to people's stories, and he told his own in response:

> And so I am here, unintentionally fulfilling a dream that some of my ancestors in Poland, Galicia and the Austro-Hungarian Empire must have nurtured and spoken about for at least two centuries. And here I find myself defending the justice of the Palestinian cause against people who may be cousins of mine, and anyway against the state of Israel.

Berger's father was Jewish, although he converted early to Catholicism. His mother was a suffragette. Berger is not often, if at all, considered a Jewish writer, but in this important instance, he acknowledged his genealogy because he felt the responsibility: "Those who have been chased out, and those whom there are plans to chase out, are inseparable from the land's living pulse. Without them, this dust will have no soul. That's not a figure of speech, it's the gravest warning."[110] In the horrors seen since 2023, that prophecy has been fulfilled.

Palestinian poet Mosab Abu Toha shared a photograph in June 2024. It shows a young man under a pile of rubble. At first it seems that the photo is black-and-white, but then his brown skin

can be seen, along with a random plank of wood. It is the dust that has rendered it all grey and taken this person's life. Abu Toha attached a poem to the picture:

> The dust makes it difficult
> to distinguish a potato from an onion.
> But I can distinguish death.
> I can see it in the open mouth,
> in the closed eyes.
> I can see every one of us under the rubble.

The poem addresses what can be seen and is otherwise unspeakable. Simple description fails the moment in which a spherical solid might be a potato or an onion. Even as there is an allusion to Hamlet struggling to distinguish between a hawk and a handsaw, the rubble is "words, words, words." In its density of address to the intersection between the visible and the unspeakable, poetry takes material form, it too is rubble.

POST SHARED ON JUNE 6
BY MOSAB_ABUTOHA

Fig. 16 Instagram post QR code Mosab Abu Toha, June 6, 2024.

Berger had described how he saw in Palestine "the careful destruction of a people." He quoted the poet Mahmoud Darwish: "Ours is a country of words. Talk. Talk. Let me rest my road against a stone," a line from the 1986 poem "We Travel Like All People."[111] What happens if you rest a road against a stone? Elsewhere, Darwish had already named it "video." In his memoir of the 1982 Israeli invasion of Beirut, Darwish reflected:

> We saw in Lebanon only our image in the polished stone—an imagination that re-creates the world in its shape, not because it is deluded, but because it needs a foothold for the vision. Something like making a video: we write the script and the dialogue, we design the scenario . . . and we distribute the roles without realizing that we are the ones being cast in them. When we see our faces and our blood on the screen, we applaud the image, forgetting it's of our own making.[112]

This "video," the Latin for "I see," is both something Palestinians have made and something that deceives them. It is not a simple record of what happened.

In dense allusive thought, Darwish wondered if it could have been possible for Palestinians "to see differently." Realizing that his thought had become "entangled," he pulls up: "I don't want a correct answer, so much as a correct question." That's my goal here, too: questions, not answers.

Each time he engaged with Palestinian history, Darwish broke his paragraphs with the single word

"video." The video creates a ground of polished stone—rubble—in which to see, and with which to see. The danger lies in taking the picture for reality "because Palestine has been transformed from a homeland into a slogan."[113]

Two years earlier, Berger had published a collection of poetry and what we would now call creative non-fiction called *and our faces, my heart brief as photos* about relations between space, time, revolution, and storytelling. He tells about a dream in which his "I" had yet to be born:

> The only image of this happiness, the only contraband I could smuggle back across the frontier of full wakefulness, was not an image of myself . . . but an image of something akin to myself: the flat surface of a rock, a stone over which a skin of water flowed continuously.[114]

This "image" associates with Darwish's "video," a rock on which "something akin to myself" could be seen. I hear, too, the echo of the phrase "something akin to freedom" from Harriet Jacobs's *Incidents in the Life of a Slave Girl*.

In the opening to her lyrical and searing book, *In the Wake*, Christina Sharpe cited Darwish's memoir as part of her thinking. The wake is a triptych. It is the memorial held for the dead. It is the broken water behind a ship, whether a container ship or a slave ship. And there is being awake, alert to the way racial capitalism extracts life. Sharpe evokes "spaces of something like freedom" as she proposes "an ethics of seeing."[115]

Video is rubble, and rubble video, a space where an ethics of seeing struggles to emerge beyond the flat, unresponsive "image." This video rubble is where something akin to collective selves, something akin to freedom, can be grounded. It struggles against forgetfulness. If it has been through watching video and video stills from Gaza that such an ethics of seeing has been created, always under threat of forgetting, that "video" has been 40 odd years in the making. It is made not of pixels but rubble, rock, and blood.

Undefeated Despair

A few years later, Berger published a translation of Darwish's long poem *Mural* (2009) in collaboration with the anthropologist Rema Hammami. In his introduction, Berger remembered a dream he had after returning from the West Bank and Gaza. Standing in a desert, someone threw soil at him, which changed into strips of cloth: "These tattered rags changed again and became words, phrases. Written not by me but by the place."[116]

Rubble.

Video.

The rapid set of displacements from land to rags and words is a condensed history of Jewish diaspora, so intertwined with clothing, that is then overwritten by the land, Palestine, and haunted by the catastrophe of Zionism.

Remembering his dream, Berger saw how the "strip" of cloth evoked Gaza: "the word strip is being drenched with blood, as happened 65 years ago to the word ghetto."[117] Berger associ-

ated the medieval term "ghetto" with the Gaza Strip. Berger saw how the ghetto, first created in Venice, returned during the Holocaust, in which the newly created Jewish ghettos in Warsaw, Łódź, and many other places were "liquidated." To convey all this, Berger coined the term "land-swept," meaning "a place or places where everything, both material and immaterial, has been brushed aside, purloined, swept away, blown down, irrigated off, everything except the touchable earth."[118] The land must be swept every day to remove the rubble.

Today I saw a photograph of civil defense workers in Gaza, sweeping rubble aside by hand in the heat to create walkable highways. Another photograph depicted two women calmly walking amid towers of debris along such on a flat sanded route. Berger called this spirit in Palestine "undefeated despair," meaning "despair without fear, without resignation, without a sense of defeat."[119] Perhaps an idiosyncratic translation of the Arabic *sumud*, usually translated as "steadfastness," "undefeated despair" resonates again today.

In a further effort to explain what "landswept" meant, Berger evoked *Puppet Theater* (2008), an installation by Palestinian artist Randa Maddah (b. 1983). While Berger saw Puppet Theater amid the rubble of an abandoned underground parking lot in Ramallah, Maddah later exhibited at the Venice Biennale in 2019 and is now a founding member of Fateh Al Mudarris Center for Arts and Culture in the occupied Golan Heights. Her installation consists of a large bas-relief and three life-size figures. The relief forms an audience of

"shoulders, faces and hands" for the three figures as they crash into the ground, suspended by strings manipulated by an unseen puppeteer.[120] For Berger, Maddah's installation was a land-changing prophecy: "It has claimed the very ground on which it is standing. It has made the killing field between the unreal spectators and the agonizing victims sacred. This unforgettable work prophesied the Gaza Strip."[121] It is video. Darwish and Berger together prophesied Gaza since October 7th, where video has become the "foothold" for another way of seeing.

In October 2023, the Palestinian Museum in Birzeit tore down an exhibit on music that had been intended to open and instead created a display of art from Gaza under the title "This Is Not An Exhibition." The walls and texts from the failed exhibit were piled up in the center of the space as rubble. As the museum wrote, it is "preposterous to even think about creating a conventional exhibition [a]s the machine of killing and destruction continues to transform the urban and natural landscape in the Gaza Strip into endless grey masses, acting as a black hole devouring all color and detail, minuscule and profound alike, and where death is hunting down all iterations of life."[122] Five of the artists in the show are now dead. Undefeated despair.

Amnesia Repelled

Palestinian artists Basel Abbas and Ruanne Abou-Rahme have found the means to connect rubble, undefeated despair, and video in their ongoing

digital project *May amnesia never kiss us on the mouth* (2022–present). Using an open digital format, based around hyperlinks and a database like much of the pre-platform internet, Abbas and Abou-Rahme have assembled a collection of "found video," comprising short videos posted online from Iraq, Palestine, and Syria, highlighting song and popular music, including protest chants. They are assembled on screens or webpages alongside nature photography and a set of performances created in response to the videos. The interface is embodied, involving word, body, music, dance, and natural beauty.

In the version housed online,[123] there is a page that highlights (literally) a 2021 essay by political theorist Nasser Abourahme, quoting John Berger's theory of rubble, and undefeated despair. Abourahme added: "If the Palestinian condition has taught us anything, it is that despair and hope are not opposites: it is never pessimism or optimism; it is always pessoptimism."[124] He referenced here the 1974 novel by Palestinian writer Emile Habiby, *The Secret Life of Saeed, the Pessoptimist*. In that term, I also hear Stuart Hall evoking Gramsci's pessimism of the intellect and optimism of the will.[125]

On the same screen as the Berger quote, also seen in Abbas and Abou-Rahme's 2022 installation at the Museum of Modern Art, are a set of videos that collectively depict undefeated despair. One is a found video of Palestinian protestors in Jerusalem, *Those Who Chant Will Not Die*. Their statement is counterintuitive to Western ears, but for those who consent not to be a single being,

there is continuity because the chant continues even if some of those chanting die. It embodies a popular countersovereignty to the power evoked in the ritual declaration, "The king is dead, long live the king": kings die; majesty does not. The chanters refuse to accept the domination of armies: chanters die; the people do not.

In the performers' videos alongside, they sing and perform an expressive gesture with both arms raised and bent up at the elbow, hands open and gesturing away from the body. The movement ends with one performer singing as the others watch. In the adjacent short video, a performer works more forcefully, head pumping up and down to a rhythm we can't hear, hands beating time on the chest, and finally simply clapping. The third scene reprises the chant from the first. One performer lies on the floor, arms crossed, and another stands with their back to him but the third helps him up. The three raise arms and return to the haunting chant.

Rubble.

Video.

Undefeated despair.

Autopsy

I want to perform an autopsy. In the older senses: "The action or process of seeing with one's own eyes; personal observation, inspection, or experience." Or: "witnessing." Literally, autopsy means seeing the self (from the Greek *auto*, self, and *opsis*, sight, which gives us optic). The subject of this autopsy is the set of damaged selves within my body. Some are alive. Others are not. These selves often get in each other's way, sometimes intentionally, sometimes not.

It's not a question of dissecting the body, so much as tracking how and when the selves that inhabit, animate, and dissociate this corporeal form came into being or ceased to be. By excavating these layers of self in time-space, I work backwards into "sight," in order to displace white sight. The question isn't: "what did you see?" as if to an eyewitness. It's more like: "What selves do what seeing in what relation to which space and time?"

Jewish Bodies

My body is the product of three collapsing empires—Ottoman, Russian, and British—that allowed the refugees and migrants that constitute my family to meet. Such migrant histories are often romanticized. Let's say this otherwise. There's so much violence in (making) this body.

Armed violence for Zionist groups against the British in Palestine. Domestic violence in Jerusalem, London, and New York over the decades. Sexual assault in all those places.

For me—not necessarily for you, I know—these personal and family histories are part and parcel of what it is to have been Jewish. Such histories intersect and inform the colonial violence in Palestine from 1948 to the present. I want to stay in this place: that whatever being a "Jew" means circles around violence, both violence done to Jews, as is canonical, and by them, which is not.

So much of the politics since October 7th has centered on terms like "the Jewish people," or simply Jews. The famously complicated debates as to how these qualities might be defined has been resolved by making antisemitism once again the determining factor. Since 2020, a hitherto obscure organization called the International Holocaust Remembrance Association (IHRA) has come to dominate the definition of antisemitism as a "quasi-law," a set of regulations "borrowing from the coercive force of the law, while lacking democratic legitimacy.[126]

As the descendant both of some of those who did not survive the Holocaust and some who did, I take this question very seriously. I am not convinced the IHRA do. Defining antisemitism vaguely as "hatred towards Jews," its central example is "targeting of the state of Israel." The individual Jew disappears into the state of Israel, like a latter-day Leviathan. This merging of people into the state can itself be understood as

antisemitic, given the old charge of dual loyalty made against Jews.

No less than seven of the eleven examples of antisemitism given by the IHRA concern Israel. With the recent adoption of the IHRA definition by US universities including Columbia and NYU, it is uncertain if academic work criticizing Israel will continue to enjoy the free speech protections usually allowed in US higher education. Ironically, it was just a moment ago that the same institutions were arguing that racist and white supremacist speech must be given such freedom. Palestine is, once again, the exception that proves the rule.

By contrast, the 2022 Jerusalem Declaration Against Antisemitism, drawn up by hundreds of scholars working in fields such as Jewish studies, Holocaust studies and memory studies, sees the struggle against antisemitism as inseparable from that against "all forms of racial, ethnic, cultural, religious, and gender discrimination." Parsing matters far more carefully, the Declaration holds that supporting Palestinian rights or criticizing Zionism is not antisemitic, whereas linking Jews or Israel to "forces of evil" would be.[127] However, university taskforces on antisemitism at Brown, Columbia, CUNY, Harvard, and Penn have all opted either to recognize a range of definitions or to create one of their own.

While I might previously have welcomed a broad social consensus against antisemitism, as an anti-Zionist Jew I feel just as targeted by the new anti-antisemitism as by antisemitism of the old school. In March 2024, German officials canceled an exhibition by South African Jewish

artist Candice Breitz at the Saarland Museum in Saarbrücken, not because of anything in her work but because they defined her social media posts as "antisemitic." She is nothing of the kind. But she opposes Zionism, which is a political philosophy, not a person, let alone an ethnicity. Not for nothing have artists and scholars called such censoring responses to ideas a new McCarthyism.

The History of Violence

It's personal. And it's political, part of the dissociation I have to overcome to "see" Palestine. I have to see in the dark composed both of the violent Jewish colonization of Palestine, and the domestic and sexual violence that took place "out of sight."

When I curated a 2018 exhibit at the Center for Art Migration Politics (CAMP) in Copenhagen, I met a woman who used the phrase "when I was on the boat," meaning the inflatable that took her to Greece from Turkey. It resonated because my grandmother used the same phrase many times to describe her journey as a refugee from Samarkand to Palestine around 1923. I often thought about that moment when she stepped off the boat onto what was then the British Mandate in Palestine. On the boat, she was a refugee. When she set foot in Palestine, it was as if a long-gestating metamorphosis had been completed and she emerged from her chrysalis as a settler.

For Édouard Glissant, "every diaspora is the passage from unity to multiplicity."[128] To become a settler was the exact opposite: a passage from multiplicity to one single identity. For different

members of my family, the metamorphosis was from Russian, Bukharan, Jewish, migrant, refugee, failed revolutionary, or bourgeois merchant, to simply Zionist. And that too is my dark.

There was the dark of my great-grandfather's house on what is now Mea Sharim Street in the ultra-Orthodox district of Jerusalem. In some cranny hid my great-uncle Harry Mirzoeff, who had joined the Irgun, widely regarded as a terrorist organization. British soldiers searched but somehow managed not to find him. The Irgun believed, according to their theorist Victor Jabotinsky: "Voluntary conciliation between the Palestinian Arabs and us is out of the question."[129] This is the dark.

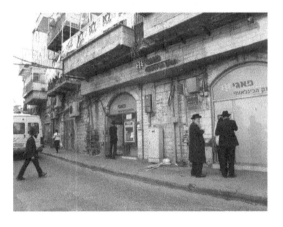

Fig. 17 Site of former Mirzoeff family house in Mea Sharim, Jerusalem (2016).

My grandmother Pnina Asheroff (1912–2009) often recalled being a fighter in the Haganah, the Jewish militia that later became the core of the IDF. Again, terrorists to the British.[130] If true, she was one of very few women in the Haganah in its

early days. What she remembered most, and often spoke about, was being asked to assemble weapons in the dark. That fits with historians' accounts of the Haganah. There's even a museum in Tel Aviv called the Ayalon Institute that commemorates women making ammunition underground in the dark.

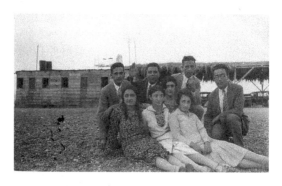

Fig. 18 Pnina Asheroff with family in Palestine (front row, center) 1920s–30s. Photographer unknown.

In her recent family memoir, the intellectual historian Or Rosenboim, my cousin, adds details I had not known: "[Pnina] discovered that she was a good shot and soon became the commander of a group of ten young women who met at night."[131] Pnina recalled to my brother Sacha (in a recorded conversation) that the Haganah always met in darkness, so "you never knew who you were standing next to."

Long before 1917, both my great-grandfathers on my father's side had bought houses in Jerusalem from a combination of business and religious motives. The legend goes that the Mirzoeffs left Bukhara earlier, around 1918, and kept more of

their money. The Asheroffs, my grandmother's family, were not as well organized and most of their resources went in financing their exit from Samarkand around 1923. They had to use fake Afghan passports to travel, which cost a great deal.[132]

Pnina met and married my grandfather Eliachar Mirzoeff in Jerusalem under the British mandate. There are differing versions of how this happened and what it meant. My grandmother used to say that Eliachar's mother had picked her to marry him and sent them on a date to the cinema to seal the deal. In other words, an arranged marriage.

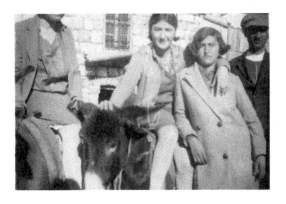

Fig. 19 Pnina Asheroff in Palestine.

Or Rosenboim says they just met at the cinema. She sees Pnina as an example of "emancipation"[133] *avant la lettre*, someone who would not have agreed to a feudal marriage. I see what she means because the photographs that survive from that time are striking. But it was Pnina who told the story.

These small family snapshots, now collated by my sister-in-law Joanne Mirzoeff into a digital archive, somehow survived many moves and burglaries over the past century. The rubble of diaspora and settler colonialism. All the subjects look at the camera with fixed stares in the bright light. Surrounded by her siblings, Pnina is the only one looking away at someone or something we can't see. It has a defiant feel. Perched on a donkey, perhaps at her older brother's farm, she commands the scene.

There's another set of stories from other cousins—there were eight siblings in Pnina's generation, so there is an extended web of family. After Pnina and Eliachar were married in 1932, there are accounts of one or more forced terminations. The motive was said to be so that she could attend to her husband without distractions. If these stories are true, it is what it sounds like—violent patriarchy. When asked about such moments, my grandmother would say "we'll jump over that," according to her Israeli niece.

As soon as I heard this story, I remembered certain moments in their house in North London, where all the doors were shut, and nothing was said. The dark, again. When I asked my cousin Natalie if there was domestic violence, she said "of course," in a very matter of fact way. This is my dissociative memory. I shut out what might have caused me to ask questions.

My Dark

In one sentence: I was sexually assaulted at the age of eleven at St Paul's School, a British public

school, where I was already marked as an outsider because I was Jewish.

I tell you this not as confessional—I already told 3,500 of my closest friends via social media in a rage post during the Brett Kavanaugh confirmation hearings—but because it is a case study of the violent colonial system that trained young men to be colonizers, that imposed and maintained the Mandate in Palestine, and that continues to underpin Anglophone racial hierarchy.

Perhaps it's easier to process as a story. That's my hope, anyway.

I repressed it all for decades. My only trace of it was a recurring nightmare. It was always dark. I could not see anything other than two circles. And I felt a heavy weight, making it impossible to move, and intrusive touching.

The accounts of people buried under rubble in Gaza evoke this nightmare for me, by the imperfect "logics" of association, not because they are the same.

I spent a long time trying to psychoanalyze that dark in my dream. It was a mistake. During the pandemic, when there was no way to evade it all, I finally realized that it was a memory, not a Freudian symbol. The weight, the dark.

My face was being pressed into the abuser's dark clothing by his weight, making it impossible to move. The circles were the frame of my National Health glasses.

I spent a decade at very Christian St. Paul's, a spectacularly violent and abusive environment. I was a visibly Jewish kid—a quota on non-Christian students was set at 25%—and literally

an outsider. After Christian prayers, Jews (and the one or two Muslims) were marched through an outdoor courtyard into the back of the assembly hall for the privilege of hearing that day's announcements. Everyone knew who was who.

The school was, like so many of its kind, filled with abusers.[134] One brave boy just before my time had reported being assaulted by music teacher Alan Doggett (who helped compose *Joseph and the Amazing Technicolour Dreamcoat* with Andrew Lloyd Webber), a founder of the Paedophile Information Exchange. The student was punished.

Accordingly, no one much cared in the spring of 1973 when David Sansom, a geography teacher, assaulted me in a small stationery supply room. The version of me that went into that room did not come out. That self was, in effect, "dead." No longer a single person, I learned to survive by dissociating. I have no "raw" details in the manner of the modern memoir, no blow-by-blow revelations.

I have a letter. Henry Collis, then the headmaster of the school, wrote it to my parents in March 1973 to explain why I was being disciplined for a drop off in academic performance. It was immediately after the assault.

Collis, a tall man in a three-piece suit, intimidated students and parents alike with his clipped military manner. With disingenuous hypocrisy, he noted he was puzzled to see I was in a "strange state at the moment because having always been cheerful to talk to he is now rather down at the mouth and not a lot comes out of it."

I had no doubt after reading this letter, sent to me by my mother via email during the pandemic,

that this assault that I had so long denied to myself had happened. A "bad patch" said the head teacher. Here, finally, having sat in a drawer in my parents' house for nearly 50 years, was what I thought to be a "smoking gun."

Despite this evidence, in 2021 the Metropolitan Police in London labeled my case "NFA," meaning No Further Action, because the abuser "no comment"-ed throughout his interview. Only the abuser's speech convicts in "historic" cases.

Even the trained police officer who questioned him was stunned by Sansom's code-switch from polite chat beforehand to sneering aggression under questioning.

When a national scandal erupted in the UK in 2012 after the death of TV star Jimmy Savile, who was found to have been a lifelong serial abuser, police investigations, arrests, and convictions of St. Paul's teachers finally followed in 2014 and after.

Teachers had assaulted and abused so many at St Paul's, the Metropolitan Police set up a special unit just to deal with them. While many offenders had died, 18 teachers were investigated for "historic" offenses with 180 known "victims."[135]

Beginning in 2014, Sansom was convicted of a string of offenses, which should mean he spends the rest of his life in a prison dedicated to sex offenders in Bristol. As an abolitionist, I'm conflicted about this. My therapist says some people are just not safe to let out at our current state of knowledge.

The full history was documented in a report by Richmond-upon-Thames council, even though

it was designed only to "identify lessons relevant for safeguarding children today." Abusers were not named so it's hard to decipher. Even the social work jargon reveals how the school created a "culture where physical violence by staff and between pupils was prevalent and the dominant culture was one of accepting both physical and sexual violence as a 'rite of passage'."[136]

Since the IDF began their punitive mission in Gaza, I've been having a different recurrent dream. It's not dark. I'm punching a person and being punched. The violence is cartoon-like, it isn't scary. There are three visually identical people in rotation, who are nonetheless different. One is my father, and one is one of my selves. The figure looks like my father, but as he looked when young, before I consciously remember. This dream-image has been, as it were, re-released by the unconscious from an earlier moment.

The other figure is the abuser in the non-linear time of the dream. I don't think this is (just) the classic Freudian Oedipus complex. It's an unsatisfiable resentment: why did "you" not protect me? Addressed to my father, the institution, and to the psychic version of myself that I used to believe was omnipotent, as little boys do.

This "self" has re-emerged in parallel with Israel's seemingly endless attacks, designed to repair its psychic dominance, by association with the affective charge of the war. Even in trying to come to terms with abuse, my hurt is not entirely from without but from within, where that is not a simple place.

This self "attacks" its-selves because it did not, and cannot, protect all these selves by itself. A sense of failure, of responsibility, of implication, of realizing that not being there does not exclude me from blame. This circuit is not fully legible to the me that writes here, being overdetermined by psychic mechanisms of condensation and displacement.

To frame this as what the Zionists call "self-hatred" is to reduce the complex psychic interface into a simplistic binary. The dream is the recognition that the self is not one. It's not a mirror, it's a kaleidoscope. The pattern I think I can see in it is a mixture of displaced and dissociated fragments, some living, some dead, some phantasmatic.

This is what "to see in the dark" evokes for me. October 7th triggered all that again.

Structure Not Event

What happened to me wasn't bad luck. It was a structure, not an event. It wasn't a cluster of abusive teachers in one school. It wasn't a side effect of the 1960s sexual revolution. It was a systemic component of the way Britain created a class of colonial officials, who were ready to inflict violence because they had come to see it as a standard feature of institutional life. Certainly, that life was one of privilege. Feel free to denounce me for that, as long as you also understand how the colonial form of that privilege was created and sustained by violence and sexual assault, visited first on British children, so that they could then deploy the same tactics in the Empire.

This systemic sexualized violence was so pervasive that in addition to my school, I've since learned that a brothel catering to men desiring children operated next door to the newsagent where I did my paper round.

Just over the river at the BBC's Television Centre, where I had my first job at 18, Jimmy Savile and his ilk were assaulting whoever they liked, protected by their celebrity and by the ratings their TV and radio programs generated.

When I went to college, one of my fellow students was Ghislaine Maxwell, daughter of millionaire Jewish publisher and Holocaust survivor Robert Maxwell, later Jeffrey Epstein's procuress and partner. I knew her only in the way that you do living in a building with a few hundred others, but she was very visible as part of elite Oxford society. When she became notorious, I asked all my friends what she had studied. No one knew. French, it turned out. We became quasi-neighbors again when Maxwell was incarcerated for two years in Brooklyn's Metropolitan Detention Center.

I now teach in the Steinhardt School of Culture, Education and Human Development at New York University. The school took on the name of former hedge fund manager Michael Steinhardt in 2001, before I arrived, in exchange for a relatively modest $10 million endowment. In 2019, a report in the *New York Times* credibly accused Steinhardt of serial sexual harassment:

"He set a horrifying standard of what women who work in the Jewish community were

expected to endure," said Rabbi Rachel Sabath Beit-Halachmi, a Jewish scholar. She said Mr. Steinhardt suggested that she become his concubine while he was funding her first rabbinical position in the mid-1990s.[137]

I've taught in higher education for 30 years. In all the places I have worked there were issues of sexual harassment and bullying. Structure not event.

Legalized Lawlessness

From my microhistory, I have come to see how the colonizer's capacity for violence is learned domestically and then applied professionally. By domestically, I mean the place the colonizer calls home, not the family residence, meaning a series of institutions from schools to hospitals, sports clubs, media outlets, and political institutions. In other words, it's all of civil society, including both the Church of England and Catholic churches.

These abusive institutions shaped and structured the class that implemented the British mandate in Palestine (1917–48). At St. Paul's, one of the nicer spaces was called the Montgomery Room, after Field Marshal Bernard Montgomery, who had attended the school and commanded British forces in Palestine before leading Allied forces in Europe in World War Two. In 1938, Montgomery ordered Palestinian rebels "must be hunted down relentlessly," using a "shoot to kill" policy.[138] He had the official manual authorize "the use of any degree of force necessary" to

end the Palestinian uprising of 1936–9 (known to the British as the Arab Revolt).[139] This capacity for violence was taught to British colonizers at public school.

At the next level of command down in Mandate-era Palestine was Captain Orde Wingate, commander of the notorious Special Night Squads. What would now be called counterinsurgents, these Squads used humiliation, torture, and collective punishment. Wingate attended Charterhouse School, which has regular sexual abuse scandals to this day. As a military cadet at the Royal Military Academy, he was subject to hazing rituals involving nudity and violence.[140]

This training served him well in Palestine. Wingate passed his skills on to Jewish insurgents in the Haganah. Zionist leader Chaim Weizman hailed "the salutary moral effect" of Wingate's tactics.[141] He was using "morality" in the imperial sense. For example, Sir Hugh Trenchard of the Royal Air Force hailed the "moral effect of bombing." That effect was to produce consent by force, and to reduce or eliminate resistance. Moshe Dayan, later Israel's defense minister, claimed Wingate had "taught us everything we know."[142] Today, the IDF claims to be the most moral army in the world.

While it is commonplace to hear about Islamic homophobia, it was the Mandate that introduced state-sponsored homophobia into Palestine. In 1936, it passed a statute against "sodomy," based on a similar law in India. As Hussein Omar has argued: "Ironically, those British officials imagined they were overriding a 'national institution' and

forcefully yanking Palestine backward into the purview of a universally liberal civilization."[143] Creating "sodomy" as a criminal offense was part and parcel of the violence of settler colonialism.

Historian Caroline Elkins has exposed the astonishing use of illegal violence in the latter stages of the British Empire (1910—the present). One detail to give the flavor of her account: British agents sank ships full of Jewish refugees trying to get to Palestine and used the media to blame Arabs. She sees the repression of the Arab Revolt by the Mandate as "a crucial moment in the evolution of legalized lawlessness in the Empire."[144] For Elkins, this legalized lawlessness defines imperial rule. It continues to structure settler colonialism in Palestine today.

Civilization?

The consequences of all this can be seen in Gaza. The Mandate built an 80-mile barbed wire wall, under the command of Anglo-Irish policeman Charles Tegart[145] that foreshadowed the triple fence around all of Gaza. Bombing at will, the IDF continues the practices of the 1930s RAF. Under the command of Arthur "Bomber" Harris, who would later command the firestorm bombing of Dresden, the RAF inflicted half of all casualties during the Arab Revolt.

The excessive response was intended not only to create consent but, to use the colonial term, which has recurred since October 7th, to "civilize." This imperative of nineteenth-century imperialism was given voice by novelist Victor Hugo in

1849: "To be burned by France is to begin to be enlightened." Nineteenth-century empire builders believed in the necessity, as Joseph Conrad's character Kurtz puts it in his 1899 novella *Heart of Darkness*, to "exterminate all the brutes." The book ends with the realization that the darkness was all around the storyteller in London, at the heart of the empire.

Similarly, Israel's president Isaac Herzog claimed in December 2023: "This war is a war that is not only between Israel and Hamas. It's a war that is intended, really, truly, to save Western civilization, to save the values of Western civilization." Netanyahu, for his part, greeted US military aid as the means to "defend Western civilization." For Israel's supporters, this is beyond even what neo-conservative Samuel Huntington once called a "clash of civilizations." Prolific blogger and writer Sam Harris claimed in January 2024 "real civilization—what we mean by 'civilization' at this point in the twenty-first century—exists on only one side."[146] Meaning Israel.

One of the central pieces of "evidence" for this claim was alleged rape and sexual violence perpetrated by Palestinians on October 7th. Lurid accusations made by members of a first-responder group called Zaka were given extensive media coverage, including by the *New York Times*, although it became clear they were based on speculation, not evidence.[147] An investigation into sexual violence by the United Nations did not meet any survivors/victims of sexual violence from October 7th. Despite this, and the lack of forensic evidence, the UN group concluded "there

are reasonable grounds to believe that conflict-related sexual violence occurred."[148]

These widely covered allegations have all but silenced "the well-documented claims of sexual violence against Palestinian women, men, and children that Palestinian women and feminists have been decrying since 1948."[149] There is no simple binary between (Jewish) civilization and (Palestinian) barbarism here.

A School for Colonizers

As its continuing obsession with empire shows, England has not outgrown its own imperial legacy. Present-day revelations serve as a lens by which to understand the past. Throughout 2024, revelations of abuse at the most elite British schools continued. Princess Diana's brother, Charles Spencer, revealed that from the age of eight he was subjected to "casual cruelty, sexual assault and other perversions" at his school. Reviewing Spencer's memoir, the poet Andrew Motion observed

> one of the original aims of such places as Maidwell, and the public schools for which they acted as feeders, was to desensitise boys so that they could endure the isolation of colonial service overseas and reproduce the strategic injustice they had previously known themselves. When the British empire eventually crumbled, these insults were concentrated within the organisation of politics at home—as they still are today.[150]

To be precise, children were prepared for isolation and the segregation that colonialism required; they were desensitized to violence; and learned to take the practices of violence and sexual assault as given; and then to inflict it themselves, first on their peers at school, later on their subordinates in the colonies, and finally in British politics.

Some realized how this process had worked on them. In March 2024, a court heard of the systemic abuse at Edinburgh's elite Brownlee Academy. According to a report in the *Guardian*:

> Neil McDonald, a former army major, said self-loathing drove him to reckless, suicidal conduct in war zones. "I hate myself," he told the court bluntly. "I see myself as a loathsome piece of shit. I can't stand being me. Because I was taught that that was what we were."[151]

Again, this was systemic not an individual event. While it was literally front-page news in 2024, it has been revealed many times. During the trials of teachers at St. Paul's in 2014, one of my contemporaries there said: "We learn to hate and humiliate one another. The most sympathetically advanced among us come to hate themselves, too."

If there is self-hatred, it is that created by and in the colonizer, not those opposed to colonization. In fact, self-hatred is the method of making colonizers. To survive in such a system, it's necessary to forget and dissociate as personal survival tactics. What's this like? A daily example: I have recurrent anxieties about where my keys and

wallet are. I do actually lose them from time to time. On the subway one day, I am suddenly concerned about losing my wallet. The next thing "I" know my hand is on my wallet in my bag. In the brief interim, I had reached down, opened the bag, seen the wallet and reached for it, the work of a few seconds. But the "I" that felt the physical object in its hand did not experience those few seconds. The only cue to the missed fragment of time was the sensation of the object in my hand. There must be other times when "I" don't notice such checking outs. I have no control over them.

It happens at the societal level, too. Britain continues to uphold its empire as a good moral example. There have been articles making the "case for colonialism." In a journal called *Third World Quarterly* (no, no footnote). Lessons were not learned.

Darkness in Israel

Questions of strength, weakness and safety have become central to the assertions of revived antisemitism since October 7th. I have seen Jewish New Yorkers in supremely secure locations like Westchester and Morningside Heights declare that they do not feel safe. Across the US, Jewish students on campuses from Columbia to UCLA repeated this sentiment.

There is a difference between being challenged in a political belief that was previously taken to be unassailable, such as support for the state of Israel, and being physically unsafe. Some are being instrumental, trying to create political advantage.

I've seen trusted friends and colleagues express similar sentiments. These Jews were expressing a sense of being psychically unsafe that felt real to them.

This sentiment crosses national divides and is central to the now-strongly asserted connection between Zionism and being Jewish. Many Israelis have said something along the lines of novelist Dorit Rabinyan, quoted by the *New York Times* in December 2023: "At that moment, our Israeli identity felt so crushed. It felt like 75 years of sovereignty, of Israeliness, had—in a snap—disappeared. We used to be Israelis. Now we are Jewish."[152] Rabinyan implied that without absolute sovereignty, Jews are necessarily weak. Because Jews have no sovereignty, they get attacked. Israelis supposedly do not. Notably, there's no mention of the attacker. The blame is internal, a fault within the psyche and the body that deserves punishment.

This concept of the Israeli state is patently anti-Jewish. The "sovereignty" it claims is not a social contract in the sense of Thomas Hobbes because it excludes, at a minimum, the two million Palestinians still living in Palestine '48. Israel's colonial messianism is no longer confined to the ultra-Orthodox but is quite literally its raison d'état. By the same token, Germany has asserted that its *Staatsräson*—the reason for having a state—includes the defense of Israel.

Rabinyan is not an extremist by Israeli standards. She even had a book banned in Israel for describing a love affair between a Jewish woman and a Palestinian (although she uses the term

"Arab"). In her account of this book, *All The Rivers*, Rabinyan expresses the same fear that she would see realized on October 7th: "the Jewish fear of losing our identity in the Middle East."[153]

In challenging, however gently, what she calls "the Zionist teaching of separateness," Rabinyan was banned, spat at in the street and subjected to the kind of online attacks that have been so prevalent since October 7th. This violence is a version of white replacement panic in the settler colony: the settler knows perfectly well they rely on violence to survive and at some level blames themselves. That guilt is externalized as violence toward the colonized. Any insider who questions colonial whiteness is treated as a traitor.

For all that, writing in the days after the Hamas attacks, Rabinyan proclaimed Israel to be "united" in the belief in the country's military superiority, across all its political and cultural divides as it confronted what she called "abysmal darkness."[154] And so Israel lays claim even to the dark, even to the zones it has excluded, even to spaces of resistance. That there is no single viewpoint cuts both ways. I do not get to be in the dark alone. But then I never was.

Legacies

For those who "consent not to be a single being,"[155] the self is a projection of white sight. Rejecting René Descartes' philosophical principle "I think therefore I am," Algerian-French decolonial activist Houria Bouteldja describes what Descartes means: "I think therefore I am the

one who decides, I think therefore I am the one who dominates, I think therefore I am the one who subjugates, pillages, steals, rapes, commits genocide."[156] If the cogito, as Descartes's formula is known, is the logic of violence, then it should be refused.

Following Claire Fontaine, I call that refusal the "human strike." It is a strike against the notion of the human as violent domination and against the belief in a hierarchy of the human. Jews are not perfect, and Palestinians are not "animals." Everyone has needs and rights.

That entails, as Claire Fontaine put it, "the question, 'How do we become something other than what we are?'"[157] The "we" here can be understood in many ways. At one level, it implies everyone. At another, all those who currently benefit from the hierarchy of the human by being white in Europe or the United States, or by being Jewish in Palestine.

Since October 7th, the genocide requires other ways to be a "Jew." If Jews are perpetrators of genocide as well as its object, then everything about being Jewish has to change. Set aside being the perfect victim or the one for whom all violence is justifiable.

Refuse to be a single entity created in God's image, the *imago dei*, which haunts all Western forms of visual culture. Such perfection makes any involvement with any "other" a sacrilege. It prohibits allowing them the right to look and bans any consent not to be a single being.

To sustain supremacy, the "Jew" must be completely separate from the "Palestinian." Just like all

the other sad colonial binaries. Remember Camus siding with his mother over the Algerian resistance, just because. My country, my people, right or wrong. "Exterminate all the brutes."

And then there comes that moment of shame, where all the specialness and being chosen falls away, and to be that person, whether French, British, or Jewish, is just another way to say colonizer.

In the middle of all this, I came across a line from the artist Cindy Sherman that spoke to me: "I'm trying to get to a point where I'm basically not recognizing myself." [158] This is the dissociative vision I'm talking about here. It's a way of first recognizing and then attempting to unbuild the violences of white sight.

This work only makes sense in series, as relays of efforts to not recognize the self, which is to say, to begin the human strike.

Bodies must be autonomous, yet selves are not single. That paradox is the understanding that contradiction might offer a way to "learn how to live, finally," as philosopher Jacques Derrida put it.[159]

It is, I now realize, a late life project, one undertaken in retrospect, just as this unfolding of my various selves has been. Can I, can you, can we pivot and take what has been learned to shape a different future?

Slash the Screen

Slash the screen! It sounds like a cross between an old-school HTML computer instruction <screen/> and the violence of a slasher movie. Tijuana activist thinker Sayak Valencia calls this hybrid "gore capitalism," meaning "the reinterpretation of the hegemonic global economy in (geographic) border spaces." Its signature is the "unjustified bloodshed that is the price the Third World pays for adhering to the increasingly demanding logic of capitalism."[160]

Since October 7th, the border space that is Gaza has become a key locus of present-day gore capitalism. It's spreading as I write to Lebanon, Yemen, and other border spaces. In turn, this violence has engendered the resurfacing of an older form of decolonial feminist countervisuality. In 1914, suffragettes in Britain slashed the imperial heteropatriarchal screen by breaking

Fig. 20 Anon, "Slashed Balfour."
Photo via Palestine Action, 2024.

windows and slashing artworks. As soon as they undertook this cutting, Europe turned its colonial technologies and tactics on itself in the spasm of mass murder now remembered as the First World War, one of whose outcomes was the formation of Israel as a settler colony.

On March 8, 2024, International Women's Day, a pro-Palestine activist revisited the 1914 strategy in the face of another genocide, slashing a portrait of Lord Arthur Balfour by Philip de László (1869–1937) in Trinity College, Cambridge.[161] Balfour's 1917 Declaration as British Foreign Secretary directed the British Mandate to create a Jewish "national home" in Palestine.[162] It has not been forgotten in Palestine. An effigy of Balfour was burned on the 100th anniversary of his declaration and a 2022 exhibit in Gaza had visitors walk over his image.

Balfour is also still vividly remembered as a violent oppressor in Ireland and participated in the 1885 Berlin conference that divided Africa into a set of arbitrary colonies. A more fitting representative of British imperialism would be hard to find. To slash the colonial screen made by such men is to reveal "a tear in the world,"[163] as poet Dionne Brand has put it, specifically to tear white reality. It (re)opens the possibility of a decolonial way of seeing. In this case, it makes other pasts visible that have not been addressed. Behind the imperial screen, there are past intersections between feminist, Jewish and revolutionary ways of seeing to be rediscovered.

Why does slashing the screen, cutting the picture, have such resonance? It creates and makes palpable a countervisuality that refuses colonial visuality. Visuality is not all that there is to see.[164] It was a term coined in English by historian Thomas Carlyle, arch-reactionary and apologist for colonialism and slavery alike. For Carlyle, visuality is the way the Hero, or great man (gender entirely intended) visualizes history as it happens. While Carlyle has long been forgotten, his idea of the great man lives on from the cult of biography to the embrace of heroic leadership in national and international politics. Visuality is the colonial way of seeing, rendering the world into the "white reality" produced by white sight.[165]

Carlyle's visuality was not a practical tool. It was made so by his friend, the art critic and teacher John Ruskin. Both Ruskin and Carlyle publicly defended Governor Eyre of Jamaica when he violently repressed the Morant Bay uprising in 1865, killing over 400 people. Writing in support of Eyre, Ruskin asserted it was clear "that white emancipation not only ought to precede, but must by the law of all fate, precede, black emancipation."[166]

Ruskin had defined an imperial way of seeing to enable this emancipation in his book on perspective. Disdaining the "window on the world" technique of perspective drawing devised during the Renaissance, Ruskin imagined "an unbroken plate of crystal" a mile high and a mile wide but of no thickness.[167] In short, a screen. Ruskin further showed his students how to create what he

called a "sightline" on this screen, which looks like a rifle sight. He described to them what he called England's "manifest destiny . . . this is what she must do or perish: she must found colonies as fast and as far as she is able . . . seizing every piece of fruitful waste ground she can set her foot on."[168] Ruskin imagined empire as both an art practice and as a form of capital, always in need of circulation and expansion. Artists were to create cultural capital in the form of landscapes, portraits of empire builders, and depictions of animals. In other words, an imperial Instagram. More exactly, it's the other way around: Instagram has taken on the infrastructure of visualizing empire.

In this context, the video posted by Palestine Action is one action toward decolonizing that space, part of the general strategy created by the wave of videos from Gaza.

"Deeds Not Words"

The suffragettes clearly understood how this imperial way of seeing made empire into an immense diorama for British (white) people. Their long campaign for the franchise in Britain began at the time Ruskin created his imperial way of seeing. At first, the suffragette movement worked within the system, trying to pass legislation. When decades of effort had generated no success, activists led by Emmeline Pankhurst founded the Women's Social and Political Union (WSPU) in 1903.

The WSPU adopted direct action tactics around their slogan, "deeds not words" (Remember here

John Berger's often-repeated call for "action."
Perhaps it was his suffragette mother's motif?).
Beginning in 1908, with a great acceleration
in 1912, the WSPU broke shop, museum, and
other institutional windows as a visible sign of
the demand for women's suffrage. Emmeline
Pankhurst declared, "The argument of the broken
windowpane is the most valuable argument in
modern politics." By breaking the material glass
of capitalist circulation and display, it shattered
the imperial way of seeing through an imagined
glass screen. It created visible resistance.

Jewish suffragette Lily Delissa Joseph (1863–
1940) made being arrested for window breaking
into her art. Arrested on March 1, 1912, her exhi-
bition *Some London and Country Interiors* at the Baillie
Gallery was also opening. Alongside a review in
the *Jewish Chronicle*—then as now the house journal
for mainstream British Jews—she placed an
advertisement on the same page, apologizing for
her absence from the show's private view because
"she was detained at Holloway Gaol in connec-
tion with the Women's Suffrage Movement." This
action was her best artwork.

Following Mrs. Pankhurst's imprisonment in
1913, the feminist strike targeted art works in
museums around England as the next level of
imperial screen. In April 1913, Evelyn Manesta,
aged 25, Annie Briggs, 48, and Lilian Forrester, 33,
broke the glass on twelve pre-Raphaelite paintings
in the Manchester Art Gallery. The suffragettes
stated at their 1913 trial that they were politi-
cal offenders. That politics is still active. In 2018,
on the advice of museum staff, the artist Sonia

Boyce temporarily removed another pre-Raphaelite painting, *Hylas and the Nymphs* (1896) by John William Waterhouse as part of her "takeover" of the Manchester Art Gallery. A flurry of orchestrated and opportunistic "protest" followed, showing that these works continue to articulate a set of gendered hierarchies.[169]

The next step for the suffragettes in 1914 was to cut directly into paintings, using butchers' cleavers. The cutters were manual workers, whose cut revealed the violence of the racializing heteropatriarchal world view. Mary Richardson attacked Velazquez's *Rokeby Venus* in London's National Gallery. She explained her action: "Justice is an element of beauty as much as colour and outline on canvas . . . until the public cease to countenance human destruction the stones cast against me for this picture are each an evidence against them of artistic as well as moral and political humbug." These lines equally serve to explain the attack on Balfour's portrait (although it is a third-rate work compared to Velazquez's), despite Richardson's later turn to the far-right.

For my purposes, a still more important action was Margaret Gibb's slash of Millais's portrait of Thomas Carlyle. Despite later assertions that paintings were attacked at random, the National Portrait Gallery Warden reported on 16 July 1914 that when he "asked which the picture was . . . the woman answered 'Oh, it's the Millais *Carlyle*.'"[170] Gibb knew exactly what she was doing. It made perfect sense to cut into Carlyle's patriarchal and racist world view, to cut into visuality.

At her trial Gibb declared: "This picture will have an added value and be of great historical interest, because it has been honored by the attention of a militant."[171] For me that's true: I've been to see the painting to look at the cut that Gibb made, not because I like Millais, let alone Carlyle. What I call Gibb's *Slashed Carlyle*—a prefiguration of Dada—undid imperial visuality by cutting through Carlyle's eyes. In a photograph circulated by the National Portrait Gallery, the repaired cuts can be seen quite clearly.

Another photograph dated July 17, 1914, reproduced by the Emily Davison Lodge (organized by artists Hester Reeve and Olivia Plender) shows both these cuts and the way in which the smashed glass somehow fell within the frame and gathered inside it along the bottom edge of the picture.[172] That broken glass was rubble, counter to the "stones" thrown at Richardson and the other suffragettes.

Slashed Carlyle was already video in Darwish's sense. Through its apertures in imperial white reality, it revealed how the infrastructure of imperial heteropatriarchy contains museums and artworks as well as military and carceral institutions.

Slash 2

As is appropriate to gore capitalism with its evocation of slasher movies, there is now a sequel, even if it took over 100 years to get made. In March 2024, Palestine Action slashed and threw paint on Balfour's portrait in Trinity College.

This action followed their paint-throwing attack on another portrait of Balfour in the House of Commons, itself echoing suffragette Sylvia Pankhurst throwing a stone at a portrait of the Speaker in 1913. Reeve and Plender had created an "imagined photograph" of Pankhurst's action in 2014.

No need for that in 2024, as Palestine Action videoed the event and posted it online. The video opens on a tight view of the Balfour portrait, with a white bust of some other dignitary also in frame. In front of the picture, a smartly dressed activist wearing a stylish leather backpack is busy spray painting the picture red. They try to concentrate the paint on Balfour's face, covering its bottom right quadrant, but the picture is hanging a little too high for them to reach it all.

There's a cut (as in edit) and then they are seen slashing the canvas. First, they cut a rough cross, followed by vertical slashes and a circular movement. They are holding a piece of paper in their left hand, which they consult during the

POST SHARED ON MARCH 8
BY PAL_ACTION

Fig. 21 Instagram QR code
Palestine Action, March 8, 2024.

action, suggesting it was so carefully planned that the cutter was concerned they might forget some steps. These actions cause strips of the canvas to dangle.

In the still photo sequence also released by Palestine Action, a triangular section of the canvas has fallen out, revealing the wooden stretcher of the painting behind. This cutting was all in the lower section of the painting that depicts Balfour's robes and a large book he is consulting. The cutter could not reach Balfour's face. What's so striking in the video is the loud sound of the canvas being cut in short, decisive bursts, recorded close to the action. It's the sound of countervisuality. Colonial visuality is the drone's-eye-view, impersonal, top-down and mute to the viewer, although noisy to those under surveillance. Countervisuality is on the ground, embodied, messy, and resonant with the sound of resistance.

With over half-a-million views on Instagram, this performance created its audience by defying the patriarchy in one of its sanctuaries. As with Gibb's *Slashed Carlyle*, Palestine Action's *Slashed Balfour* is a (much) better, more-interesting, and more compelling work than its substrate. It was in active solidarity with videos posted from Gaza. The goal of this solidarity was to remind audiences in the UK and related nations of the 1917 British decision to create a "Jewish" state in Palestine, at a time when only 60,000 Jews—including some of my relatives—were living there. As Balfour later said, the British view was "Zionism, be it right or wrong, good or bad [is] of far more profound import than the desire and prejudices of

the 700,000 Arabs, who now inhabit that ancient land."[173] That disdainful approach remains intact today.

The cut further revealed the role of Cambridge University in general, and Trinity College in particular, as investors in Elbit Systems, an Israeli arms manufacturer. Elbit's share price fell sharply since the action from $214 on the day of the action to under $180 in June 2024 with a slight recovery since to around $190.

At the student encampments around the world, including Cambridge in April and after, the first call was to disclose and divest investments in military and Zionist projects. In May 2024, calls for Britain and the United States to stop sending weapons to Israel finally had some modest results when Biden suspended a delivery of 2,000lb megabombs to Israel.

The cut into Balfour disclosed what Oxford, Cambridge, and the Ivy League (and the fee-paying schools that feed them) were and still are to this day: imperial training schools.

Encampments

In April 2024, the war came home to the colonial metropole. A wave of Gaza solidarity encampments appeared across the US, Europe, and around the world in the wake of the genocide. Created by students in and around universities, the encampments centered around a group of tents, where occupiers lived. There were stations for food, water, and other personal needs. Banners, chants, and posters announced the solidarity project to passers-by.

While always centered on what was happening in Gaza, the central demand of the occupiers was for universities to "disclose and divest" any investments they have in the military-industrial complex and in the state of Israel. Universities furiously refused, deploying police on their own campuses to make arrests and violently break up the occupations.

While most of these encampments were brief in absolute terms, the experience was transformative, even if the declared goals of divestment and disclosure were achieved only in a minority of cases.[174] It made visible why Palestine is the world: as a struggle between institutions backed by the state or capital (in the form of "donors") against precarious students.

The encampments created a tear in white reality through which anticolonial visual activism

in solidarity with Gaza could be seen. Just as when Palestine Action slashed the portrait of Balfour so that you could see the wooden stretcher beneath that is the material support of the painting, this tear made Zionism's support network visible.

From Occupy Wall Street (2011) on, urban protest encampments have been highly visible sites of face-to-face seeing. First, occupiers place their bodies in public space and claim the right to be seen.[175] In that reclaimed urban space, normally saturated with surveillance, participants can share the right to look, to see, and be seen. Hitherto anonymous non-places, all named for some forgotten donor, became the site of an assembly, a teach-in, or an encampment.

Unlike earlier encampments, the Gaza solidarity movement also claimed the right to opacity. As a faculty member in solidarity, much of my time at the NYU encampment was spent holding up a golf umbrella to prevent pro-Israel activists from filming occupiers so that they could "doxx" people (meaning share their personal information online). It also allowed the occupiers to interact with confidence.

The three components of visible relation—the right to look, the right to be seen, the right to opacity—were all present in the encampments, which became among other achievements, the lived embodiment of visual activism. This visible, once more, is not a biological process of perception. It is a different association of the perceptions that emerged collectively through participation and solidarity.

For all their denial, universities are indeed connected to the colonial project in Palestine. As has become obvious since October 7th, the goal has been, in billionaire Michael Steinhardt's words on his own website: "Zionism should not only be about advocating for Israel and its security on the political plane but should also be about taking the best of contemporary Israeli experience and allowing it to inform the Jewish lives of Americans."[176] Financial investments, even if small in relation to the entire endowment of a major private university, are the material expression of this symbiosis.

Frantz Fanon described in *Wretched of the Earth* how "the dreams of the colonial subject are . . . dreams of action."[177] The encampments were lived dreams of action. These were dreams in the wake, the simultaneous condition of mourning and awareness. Seeing in the dark is what it is to have a dream of action in the wake amid the rubble of word and video. That the actions seen today follow the taking down of what Fanon called colonialism's "world of statues" is, in 2020, the expression of their decolonial structure.

In the space created, three visual activism tactics were seen in action: counter-masking, conviviality, and the commune. Each drew on important activist traditions, mobilizing different sectors of the solidarity coalition.

Counter-Masking

Occupations and masks go together. In 2011, Occupy Wall Street used *V for Vendetta* masks or

simple bandannas, leading the NYPD to threaten protestors with laws intended for nineteenth-century highwaymen. Occupy Central in Hong Kong also used *V for Vendetta* masks in 2019 to protect participants from China's advanced facial recognition technology.

In the 2020 COVID-19 pandemic, masks became both required in many situations and the object of intense far-right paranoia. In the Gaza encampments, masks were worn both to protect participants' health, and as a claim to the right to opacity. Fearing both university sanctions and pro-Zionist harassment if identified, masks became an accessory of choice. Universities that had until recently insisted on masks were now placed in the uncomfortable position of insisting that they be removed.

Masks evoke strong emotions because they are cultural archetypes, central to many performance cultures worldwide. Here I want to explore a set of associative, layered resonances around masking, connecting looting to Palestine and counter-occupation.

In 2022 Michael Bogdanos in the Manhattan District Attorney's Office had announced a settlement whereby financier Michael Steinhardt, a donor to many universities including NYU, was to return an estimated $80 million worth of looted art from his collection and desist from all future art trading in exchange for not receiving a criminal conviction.[178] At least 30 objects, many of great antiquity and value, had been looted from Palestine. Central to the returned art was a set of eight masks, ranging from the Neolithic

to the Bronze Age. Six were found in Steinhardt's New York City, apartment arranged on a side table in front of a Picasso. Steinhardt had enough art history to know that Picasso was influenced by masks and perhaps assumed that ancient Palestinian masks were just as good as the colonial-era African masks Picasso had seen.

In a 2016 project by Palestinian artists Basel Abbas and Ruanne Abou-Rahme, entitled *And yet my mask is powerful*,[179] these masks had been re-appropriated as part of a temporary de-occupation of Palestinian villages. Their title quotes Adrienne Rich's poem "Diving into the wreck," whom they followed into "the site of the wreckage." In my terms, wreckage is rubble, still subject to being looted by the colonizer. The result was one of Abbas and Abou-Rahme's signature 5-channel video projections, in which they recorded visits by Palestinian young people to de-occupy the sites of their ancestral villages, destroyed by Israel. The sites were sometimes identified by discovery of still-growing plant life, like cactus, fennel, or pomegranate, once cultivated there. Other-than-human life resists erasure.

Those reclaiming their land wore replicas of the Palestinian masks held in the Israel Museum, fabricated by 3-D printing, using the museum's photo of a 2014 exhibit as a blueprint. This performance was, write the artists, "becoming other, becoming anonymous in this accidental moment of ritual and myth." Different moments of time co-existed in the invented ritual. The mask "returns into virtual time and out of an occupied time."

In this action, ancient life-forms were reshaped, revived, and returned using high-end digital technology. Abbas and Abou-Rahme understand the masks as "living matter not dead artifact." They asked: "how in the face of such violence, can we then begin to retrieve and reconstitute living matter from the wreck?" This question resonates still more in the wake of Gaza's wrecking.

All manner of forms now considered museum "objects" have been understood as alive, from Byzantine icons, to the moai statues from Rapa Nui (Easter Island) or the Zuni Ahayu'da (little brothers) honored by Zuni peoples in what is now the southwest of the United States. This way of seeing is a vital addition to the consent not to be a single being—the recognition that there are other-than-human and more-than-human ways of life beyond the biologically animate.

The masks later collected by Steinhardt were not excavated by archaeologists but looted from Palestinian villages. British missionary Thomas Chaplin reported in 1890 of one such mask: "they regarded it as a kind of amulet." It had been part of village life for hundreds if not thousands of years.

The Israel Museum calls these masks an "enigma." If that is so, it is only because they had been wrenched out of their historic context, which was in turn demolished and planted over with invasive species like pine trees. Abbas and Abou-Rahme highlighted how the Israel Museum claims the masks were found at a "Neolithic site in the Judean Hills." Their annotation read: "surely perhaps you mean the West Bank." Yet this cor-

rection was never made, and when the looted masks were returned by the Manhattan DA, it was Israel that received them.

In the press release dated March 22, 2022, in which Manhattan DA Alvin L. Bragg hailed the return of the looted antiquities, including the masks, to Israel, their total value was set at "more than $5 million."[180] The release was illustrated with two gold masks from c. 7,000 BP, valued at $500,000. Three other masks were valued at $650,000. In small print below, it was noted that the Neolithic masks dating to c. 9,000 BP were valued at $3,000,000—by far the largest item. Almost all the attributed value of the repatriation of Palestinian art to Israel came from Steinhardt's looted masks.

Abbas and Abou-Rahme prefigured the yet to come "release" of the masks as imprisoned life forms. Set free, even via replica, they could again protect and maintain their land, where they had been resident since time immemorial.

Conviviality

Masked or not, the solidarity encampments were full of life and sound. They were convivial, small, peaceful, and hospitable. Such conviviality is always a counter to counterinsurgency, making it anathema to all forces of occupation from IDF to NYPD. In the dream of action, says Fanon, "I burst out laughing."

The encampments embodied a refusal to accept "business as usual" in the face of genocide. Such refusal is not negative. In the terms of the

Center for Convivial Research and Autonomy (CCRA), based in the Bay Area, through such practices, "a collective subject (always emergent) takes shape."[181] The CCRA define this work as follows: "By convivial research we mean a collective horizontal approach that refuses to objectify communities of struggle, engages multiple sites of knowledge production, and generates new strategic, conceptual tools."[182]

In this perspective, the encampments were practices of research and knowledge production. The convivial research encampment formed what the CCRA calls a "temporary autonomous zone of knowledge production."[183] It's an update to Hakim Bey's 1991 concept of the "temporary autonomous zone." This zone refused the violence of the debt-for-credits machine that the university has become, while producing new ways to imagine being together. It challenged the top-down wealth pyramid, made visible by the disparity between the precarious grounded encampment and the supertall skyscraper that is now a feature of the New York skyline. The supertall promises its inhabitants the same "security" that the financialized university now sees as a prerequisite. The encampments by contrast knew that "we keep us safe" rather than militarized police and private security.

By creating known and knowable spaces of convivial counter-counterinsurgency, encampments remapped city space. On May Day 2024, wildcat marches in New York City connected the trade union rally in downtown's Foley Square to the encampments at NYU, New School, CUNY, and

Columbia, making a different city visible. This city does not segregate or compartmentalize. It enacts David Harvey's call for the "right to the city."[184]

It was this city that was visible in the 2020 Black Lives Matter protests. This is the city that is needed in a world of pandemics and global heating. It shows how a city region can function as a complex of archipelagos, rather than a centralized hierarchy. It operates as a grounded convivial network of mutual aid, research, and insurgent learning.

Such a psychogeography of freedom and action also makes visible how the region between the river and the sea could function autonomously for all those living in it.

For those whose dynamic is rage, terror, hatred, and fear, the networked city is barbarism, whether in Palestine or New York. White "civilization," and the fear of its replacement, requires hierarchy, dominance, strength—and therefore suffering. Conviviality must be alchemically rendered into "violence" so as to sustain the colonial world.

That world is above all a world of supremacy. In May 2024, a meme showing a Confederate flag flying above an Israeli flag began to saturate far-right sectors of the Internet, suturing these two forms of supremacy. It had already been seen in practice at the January 6, 2021 insurgency, where both flags were carried.

The Commune

In the essay highlighted by Abbas and Abou-Rahme in *May amnesia not kiss us on the mouth*, political theorist Nasser Abourahme also mused

on how revolution might emerge from the camps: "What if the Palestinian Revolution, whose fate follows the rise and waning of tricontinental Third Worldism, should be read not as the defeated end of a revolutionary historical arc, but as the start of a line of flight?" From undefeated despair comes the beginning of a new way of performing revolution. No longer about the state, "the revolution was in the making of communes."[185]

There is a parallel to be drawn here with the way that James and Grace Lee Boggs drew on the defeat of the Detroit Uprising in 1967 to reimagine what they called "{r}evolution" as a different way of living in the city.[186] What if, by extension, the revulsion caused by the genocide in Gaza led to a revolutionary line of flight that went through the encampments? In his essay, Abourahme drew both on histories of Palestinian camps and other autonomous spaces like the 1871 Paris Commune.[187] He suggested that by creating communes, like the refugee camps—as we have seen even in extremis in Gaza—Palestinians prefigured "a form of life demonstrative of what decolonized society could look like," as also happened in Detroit. The encampments continued this line of flight from their temporary autonomous knowledge producing zones to the commune to come.

Mat Fournier defines a line of flight, a term first proposed by philosophers Gilles Deleuze and Felix Guattari,[188] as "the elusive moment when change happens, as it was bound to, when a threshold between two paradigms is crossed."[189] The line of flight slashes the colonial screen.

The commune is a way to live, finally, outside that colonial, even within its state. It is not a move to the future but to a complex temporality: "the general insurgency that is the global present cannot but reckon now with the wreckage of colonial history directly in its path."[190] In my terms, it's rubble. And video.

The encampments began the work of building a commune and were met with the full repressive force of the state and its infrastructure in consequence. Within the university, the knowledge-based version of surveillance capitalism, the encampments created a tentative but palpable moment of what anarchists call "dual power."[191] For anthropologist David Graeber, dual power meant (in the case of Occupy Wall Street): "By creating autonomous institutions that represent what a real democracy might be like, we could provoke a situation for a mass delegitimation of existing institutions of power."[192] The encampments had real autonomy as learning spaces, challenging the capital-intensive universities, even if it was, as the CCRA insist, inevitably temporary and always becoming.

The Palestinian revolutionary camp had its fighting and training. But it also had "debating, filming, documenting, inhabiting, building, cooking, sharing, affecting and narrating."[193] As did the encampments. To which should be added their practices of care, call-and-response, poetry, performance, singing, and more.

The camps were dismantled quickly and violently. So far going was this hostility that the Supreme Court ruled in June 2024 that all urban

camping was illegal, including, in Justice Gor-
such's patronizing language, "a student who
abandons his dorm room to camp out in protest
on the lawn of a municipal building." Security
forces have remained in place ever since and uni-
versities have changed their regulations, just to
prevent any further appearance of tents.

From the Bonus Army encampment in Wash-
ington DC in 1932 via Resurrection City in 1968
(also in DC) to Occupy Wall Street,[194] the tent
has been a powerful symbol of dual power, the
commune, and mutual aid. It continues to provoke
the fury of a state that cannot house or care for its
citizens, much less offer them anything approach-
ing democracy.

The encampments were seeds, albeit ones that
must be planted in what Casid calls a "landscape
scene of genocide . . . restless, inhabited ground
that makes us begin to sense what cannot be
seen."[195] Now that the security apparatus is so
primed to repress encampments, these seeds will
engender other ways of seeing and being together.

In keeping with long traditions, Silvia
Federici has named this set of associations as the
"commons." No commons can be a colony. There
is no white sight there. In the commons, the rights
to look, to be seen, and to claim opacity are just
that, common, everyday, every day.

Coda:
A Murmuration for Rosa

I think of what you have just read as a pamphlet in the radical tradition of Rosa Luxemburg's *Junius Pamphlet*, not because I see myself as her peer, but because I wanted to follow her example as a disabled, feminist, Jewish revolutionary, who both knew what antisemitism was and how colonialism makes instrumental use of it.

I wanted to tell you how and why I've seen this catastrophe, so you can see how it relates to your own experience and to that of others, whether you happen to be a Jew, a Palestinian or any other form of human being. I don't come with answers.

To speak of an "end" or to draw conclusions is premature. As this pamphlet goes into production, Israel appears to be set on turning Lebanon into another Gaza. Much will have happened by the time you read this.

It's not my place to suggest what Palestinians should do, or to prescribe tactics to students and others protesting. I have instead tried to make a way of seeing from the place of anti-Zionist solidarity.[196]

All the work here has been associative, from ways of seeing in the dark to rubble; and the resulting tactics of visual activism from the slashed screen to the commune.

This complex—not complicated—pattern of time-space is a murmuration. Murmurations are three-dimensional fractal patterns created by birds, often starlings, as they fly together in ephemeral and wildly beautiful patterns. Necessarily temporary, the murmuration embodies freedom in three-dimensional time-based mediation.

When colonial white sight sees from above, in what is often called the birds-eye view, it identifies with apex predators. In this countervisuality, drawing on a tradition that began with Sufi poet Attar's epic poem *Conference of The Birds* (c.1177) and Chaucer's *The Parliament of Fowls* (c. 1382) and is active in Black radical thinking today, songbirds and other "ordinary" birds play the key roles in imagining democracy, equality, and love. Like Marx's "old mole"—the revolution—this avian democracy appears and disappears over time, rather than being a constant.

The murmuration is not a single point way of seeing but a distributed one. Each bird in the murmuration chooses either to fly toward the light or to the dark created by another bird's body. The result is democracy in action, and a three-dimensional way to draw. While each bird makes an independent choice, more of them must choose the dark or the murmuration will collapse into a series of individual birds.[197]

The murmuration is the democratic choice to see in the dark and to fly together as such. It is both what abolitionist Ruth Wilson Gilmore calls an "infrastructure of feeling"[198] and an infrastructure of solidarity. Each and every murmuration is the creation of a democratic majority that sees in

the dark; but they are never the same. Seen from the rubble, a murmuration is the revolution, the parliament and conference of birds as equals, the practice of freedom.

To close, if not to end, I want to create a murmuration for Rosa, who so loved birds. As do many Palestinians. In the West Bank and Jerusalem markets, there are always a range of birds for sale as pets. Palestinians are moved by birds as an embodiment of freedom. The enclosures for the birds are elaborately decorated and, in my photograph, you can see how the stall owner has draped a piece of cloth over the upper right corner to keep the hot sun off them.

Fig. 22 Birdcage in a Hebron market, 2016.

I remembered this market day when I saw a short video by the Palestinian photographer Haneen Maher, made in June 2024. She talks with a young girl called Fatima, walking with her family from Beit Hanoun in the northeast of the Gaza Strip to the refugee camp at Al Shati' some six miles away. She had carried her bird Mansour in its cage with her because it made her feel safe. Mature beyond her years, Fatima explained: "If I live, the bird lives with me, and if my bird dies, it dies with me."

To think with Fatima's undefeated despair, I look back and forward to Rosa Luxemburg speaking and thinking with birds to find freedom in prison. It is not an exact parallel but a murmuration, an association that inhabits the multiple time-spaces of the rubble. The murmuration is a way of being together in time-space.

I place in murmuration those who both have seen and responded to Luxemburg's birds and acted in solidarity with or from Palestine: John Berger, Mahmoud Darwish, Jackie Wang, Fred Moten, Stephano Harney, and Jacqueline Rose.

POST SHARED ON JUNE 3
BY HANEEN.MAHER.SALEM

Fig. 23 QR code Haneen Maher, posted June 3, 2024.

This murmuration puts the anti-colonial forma-
tion in this pamphlet from the early twentieth
century to the present into a pattern of time-space
up in the air.

Whitechapel

Let's begin by watching Rosa in Whitechapel
in London's East End in 1907. Psychoanalytic
theorist Jacqueline Rose is here too.[199] Luxemburg
has come for a party conference, but someone has
forgotten to pick her up. She's staying at the Three
Nuns on Aldgate High Street, famous to London-
ers, but a sinister name to her. As familiar as she
was with the cities of Central Europe, London
appalled her. After a long ride on the Under-
ground, Luxemburg

> emerged both depressed and lost in a strange
> and wild part of the city . . . Groups of
> drunken people stagger with wild noise and
> shouting down the middle of the street, news-
> paper boys are also shouting, flower girls on
> the street corners, looking frightfully ugly and
> even depraved . . . It is chaos and also wild and
> strange . . . Why? Why in this life must I suffer
> these loud, piercing, slashing impressions when
> inside me, eternally, a longing for peace and
> harmony is crying?

Even if she doesn't say so, Luxemburg knows
where she is and who she's seeing in the heart of
the Jewish East End.

I find an additional resonance here. My mother's family had recently arrived in the East End from what is now Poland and Ukraine, places they so detested that they erased even the names of their hometowns. Dissociation has its histories.

My grandfather Harry Topper was at work in the East End rag trade from a young age. He worked his way up from street barrows to having his own shop selling "seconds," clothes that had defects but could still be worn.

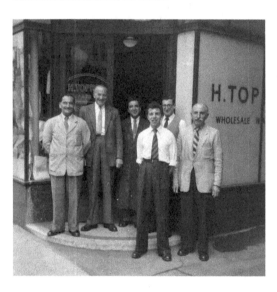

Fig. 24 Harry Topper (second from left)
outside his shop, c. 1960.

Back in 1907 Whitechapel, a music hall variety act was going on, the modern city was in full flow and then "suddenly inside me now some gypsy blood has been awakened. The shrill cords of night in the big city, with its demonic magic, have touched certain strings in the soul of the children of the great city. Somewhere in the depths an

indistinct desire is coming to light, a desire to plunge into this whirlpool." Gypsy? Not so much, I think. It's a move of dissociation and association. The identification was closer to home, a desire for wildness and the strange, prefiguring the spirit now called "Weimar," a way to be an urban Jew.

Luxemburg turns it back in time at the end, quoting a minor Jacobean tragedy:

> Bird, prime thy wing,
> Nightingale sing,
> To give my Love good-morrow.[200]

This tension between wildness, urban conflict, and time, embodied by birds, resonates across Luxemburg's writings, especially her letters from prison.

She was all too aware how antisemitism had been deployed by the Russian state to repress the wave of general strikes in the 1905 revolution. For once, she optimistically misread the flight of history: "Pogroms of Jews, absolutism's most important weapon of attack in the first phase of the revolution, are now a worn-out, unwieldy weapon." Instead, she called on revolutionaries to practice "self-examination—that is, making oneself aware at every step of the direction, logic, and basis" for the spontaneity of the uprising and general strike.[201] Revolution is wild as it flies, even as it longs for a different peace.

Carceral Murmurations

What does and did it mean to be a Jew in that chaos? From prison in 1917, she wrote a fre-

quently quoted letter to Jewish Social Democrat
Mathilde Wurm:

> What do you want with this theme of the
> "special suffering of the Jews"? I am just as
> much concerned with the poor victims on the
> rubber plantations in Putumayo, the Blacks in
> Africa with whose corpses the Europeans play
> catch . . . I have no special place in my heart for
> the [Jewish] ghetto; I feel at home in the entire
> world wherever there are clouds and birds and
> human tears.[202]

The quote is usually cited this way. In the material
removed by the ellipse, Luxemburg described the
1904 German genocide of the Overherero and
Nama peoples in what is now Namibia.

Germany still denies that the systematic slaugh-
ter, including driving people into the desert to
die, was genocide. "Genocide," it is said, did not
exist as a concept so whatever happened was mere
violence. In Germany today, there can only be one
genocide, the Holocaust.

The extermination of Indigenous peoples was
so well understood in the nineteenth century that
it was the title of an anthropology textbook. British
prime minister Lord Salisbury summarized the
prevailing consensus in 1898: "One can roughly
divide the nations of the world into the living and
the dying."[203] What happened to the Overherero
and Nama was not the same as the Holocaust, no,
but it set the frame in which genocide was and
remains thinkable, and so becomes possible.

Reading this again, I realized that the ellipse was also the title of Fady Joudah's book of poems about Gaza, written as *[...]*, a visible in relation to the unspeakable. The ellipse, I belatedly understood, was the elision of the genocide in Western eyes. With all that has happened, still we are told to "move on, there's nothing to see here."

Thinking with this unseeing back to Luxemburg, the genocide in South-West Africa—as it was then called—precluded any particular association with Jewish suffering for her. Let me restore her words from the ellipse:

> You know the words that were written about the great work of the General Staff, about Gen. Trotha's campaign in the Kalahari desert: "And the death rattles of the dying, the demented cries of those driven mad by thirst faded away in the sublime stillness of eternity," in which so many cries of anguish have faded away unheard, they resound within me so strongly that I have no special place in my heart for the [Jewish] ghetto.

Against muted colonial visuality, Luxemburg resonated with the unheard sounds of genocide. That sounding entailed a change in her relation to being Jewish. As it did for me and many others in October 2023.

From prison, Luxemburg described how she could only write "in a state of exaltation."[204] This place was "home," even in prison, In December 1917, she described at length lying awake at night after the lights were turned out:

I lie there quietly, alone, wrapped in these many-layered black veils of darkness, boredom, lack of freedom, and winter—and at the same time my heart is racing with an incomprehensible, unfamiliar inner joy as though I were walking across a radiant meadow in radiant sunshine.

Seeing in the dark found unexpected light. As she looked for "some reason for this joy, I find nothing and must smile to myself again—and laugh at myself."

That was the laugh that Fanon would later associate with the dream of action. "I believe that the secret is nothing other than life itself," she wrote, a moment of "joyful euphoria."[205] Despite war, despite genocide, despite imprisonment, Luxemburg found the way to become fully human by being in relation to what is other-than-human or more than human.

Abolitionist thinker Jackie Wang quotes this passage in full in her manifesto *Carceral Capitalism*. She too sees what Luxemburg wrote then as being now, which is not a simple form of time. To make abolition happen, Wang is looking for "a mode of thinking that does not capitulate to the realism of the Present" (her emphasis).

To be outside the consensus white reality as seen by white sight, that which was to be shattered on October 7th, Wang tarries a while with Mahmoud Darwish, quoting him on finding freedom in prison: "it is in you, borrowing the bird's example."

And so, she comes back to Rosa: "You were sensitized by your cell, by the boredom weighing you down, until the pressure of the darkness gave way to an understanding of the deepest mysteries of what it means to be alive—of the connection between desire and politics." Like Rose, Wang recognizes in Luxemburg a "true revolutionary."[206] One who recognized herself in the birds in the dark.

That dynamic was one of undefeated despair. Once incarcerated, Luxemburg knew that "prison may swallow me up at any moment."[207] She expressed the hope that she would die in service to the movement, outside prison.

She knew that these were the only choices. The German state was not going to let her survive. Friends were puzzled that during the Spartacist Uprising in 1919, whose best outcome according to Clara Zetkin would have been a "Berlin Commune," Luxemburg took few precautions for personal safety.[208] She had long accepted that the collapse of August 1914 left her presumptively dead. A shahid one might say: a witness and a martyr.

What John Berger loved about her prison letters is how Luxemburg communed with the birds.[209] She especially loved the blue titmice (*Cyanistes caeruleus*), small, sociable, and intelligent songbirds. The birds who conference, who murmur, not the predators. She suggested that the only words she wanted on her tombstone were "Tsvee-tsvee," her transliteration of their call. She could imitate it so well that they would come to her.

Luxemburg shared the anarchist Peter Kropotkin's belief that all birds collaborated when migrating: "birds of prey . . . will make that journey together in a single flock together with little songbirds, which they normally feed on . . . but during this journey a kind of God's truce, a general armistice, is in force."[210] What for Kropotkin was "mutual aid" was the supernatural truce for Luxemburg.

Writing in the depths of colonial war in Europe, Luxemburg made the truce and mutual aid into a murmuration. What if her "general armistice" was not a diplomatically mediated military process but the general strike? A refusal to persist in colonialism, formed in the matrix of the October revolution, the imperial massacre of the First World War, the Balfour Declaration, and Marcel Duchamp's *Fountain*?

What would it take to join such a murmuration? Scientists have been puzzled by the fact that birds will fly into the ground, injuring or killing themselves, to maintain their murmuration. Mickey Vallee takes their action to mean "the community moved through the body, as much as the body through the community."[211] The birds sacrifice themselves out of solidarity.

To maintain my place in the murmuration of solidarity with Palestine as an anti-Zionist Jew means "flying" in the dangerous outer edge of the murmuration, where there is risk of collision. It also means knowing how to align myself with other movements, as a sparrow, not a hawk.

In the murmuration, the racist "weapon of attack" is swarmed and disarmed by the "weapon

of theory," a term coined by revolutionary Amilcar Cabral of Guinea-Bissau as part of his address delivered to the first Tricontinental Conference of the Peoples of Asia, Africa, and Latin America in Havana.[212] That "weapon" which is not one, following Stephano Harney and Fred Moten following Cabral, leads to "suicide as a class."[213] Of "anti-Zionist Jews," for example, not to speak for others. Being anti-Zionist means being an abolitionist. Until the carceral, ethnonationalist, militarized, segregated, settler-colonial state of Israel has been abolished, it will not have been possible to be part of the class "Jews."

This decentered relation is a murmuration. Harney and Moten go on to muse on what such a "weapon" would mean:

> To feel fully the aspirations of the people to which you belong would bring about a terrible and beautiful differentiation in murmuring, an harmonic irresolution of and with and in the choir, in anticipation of a shift in flock, where belonging is in flight from belonging in sharing, at rest in an unrest of constant topographical motion. The weapon of theory is a conference of the birds.

The birds in the murmuration are ordinary, common starlings and sparrows, not the hawks and eagles of aerial warfare. The weapon of theory is a commons.

Migrants, fugitives, and commoners would be my "people to which you belong," if there was a "suicide-as-a-class." No one dies in this suicide.

It's a line of flight away from speaking my position "as" a Jew. Isn't the singular speaking subject claiming prepositional authority (that "as")—or pre-positioned power—the problem, not the solution?

The murmuration sees each other as its condition of existence, not singularly "as," but in relation and in motion, only as long as the murmuration holds. It is a temporary democracy, held together while each member decides to fly toward the dark of each other's bodies.

The murmuration is seeing in the dark, the commons that I'm working toward with Berger's "undefeated despair." The murmuration is the refusal to consent to the practices of genocide. We must gather otherwise, in our consent not to be a single being, in the rubble, seeing in the dark. Undefeated.

Notes

1. Video available at https://cracs.nyu.edu/global-feminist-critique-of-capital.
2. https://lemonde.fr/en/opinion/article/2024/03/15/judith-butler-by-calling-hamas-attacks-an-act-of-armed-resistance-rekindles-controversy-on-the-left_6621775_23.html.
3. Helga Tawil Souri and Dina Mattar (eds), *Gaza as Metaphor* (London: Hurst, 2016), pp. 3–4.
4. Norman Finkelstein, *Gaza: An Inquest into Its Martyrdom* (Berkeley: University of California Press, 2018), p. 35.
5. See Jasbir Puar, *The Right to Maim: Debility, Capacity, Disability* (Durham: Duke University Press, 2017).
6. Khatib, Rasha et al., "Counting the Dead in Gaza: Difficult but Essential," *The Lancet* 404, no. 10449, 237–8.
7. Natan Sharansky and Gil Troy, "The Un-Jews," *The Tablet* (June 16, 2021). https://tabletmag.com/sections/news/articles/the-un-jews-natan-sharansky
8. See Rashid Khalidi, *The Hundred Years' War on Palestine* (New York: Macmillan Publishers, 2020).
9. See Zoé Samudzi, "'We Are Fighting Nazis': Genocidal Fashionings of Gaza(ns) after 7 October," *Journal of Genocide Research*, (January 18, 2024): 6–7.
10. https://jewishvoiceforpeace.org/2023/10/11/statement23-10-11/
11. Raz Seghal, "A Textbook Case of Genocide," *Jewish Currents* (October 13,

2023). https://jewishcurrents.org/
a-textbook-case-of-genocide

12. https://rb.gy/9z042u

13. Nasser Abourahme, "In Tune with Their
 Time," *Radical Philosophy* 21.6 (Summer
 2024): 14.

14. See Noura Erakat, *Justice for Some: Law and
 the Question of Palestine* (Stanford: Stanford
 University Press, 2019).

15. Didier Fassin, "The Rhetoric of Denial:
 Contribution to an Archive of the Debate
 about Mass Violence in Gaza," *Journal of
 Genocide Research* (February 5, 2024): 2.

16. Isabella Hammad, *Recognizing the Stranger: On
 Palestine and Narrative* (New York: Black Cat,
 2024), p. 69.

17. Patrick Wolfe, "Settler Colonialism and the
 Elimination of the Native," *Journal of
 Genocide Research* 8, no. 4 (2006): 387–8, 398.

18. Hammad, *Recognizing the Stranger* p. 61.

19. See Nicholas Mirzoeff, *How to See the World*
 (London: Pelican, 2015).

20. Nicholas Mirzoeff, *An Introduction to Visual
 Culture*, third edition (London: Routledge,
 2023), pp. 2–7.

21. Édouard Glissant, *Poetics of Relation* (Ann
 Arbor: University of Michigan Press, 1997),
 p. 191.

22. Ibid., p. 144.

23. Manthia Diawara, "Conversation with
 Édouard Glissant Aboard the Queen Mary
 II (August 2009)." https://liverpool.ac.uk/
 media/livacuk/csis-2/blackatlantic/
 research/

24. See Fred Moten, *Black and Blur: Consent Not
 to Be a Single Being* (Durham: Duke
 University Press, 2017), pp. vii–xiv.

25. See Aparna Gopalan, "After the
 Encampments," *Jewish Currents* (September

26, 2024). https://jewishcurrents.org/after-the-encampments-gaza-university-divestment.

26. Abourahme, "In Tune with Their Time," p. 20.

27. See Stuart Hall, "Race, Articulation and Societies Structured in Dominance [1980]," *Essential Essays, Volume 1: Foundations of Cultural Studies* (Durham: Duke University Press, 2018), pp. 172–221.

28. Charles E. Calwell, *Small Wars: Their Principles and Practice* (London: H.M. Stationery Office, 1906).

29. Haleema Shah, "Is Israel a "Settler-Colonial" State? The Debate, Explained," *Vox* (April 17, 2024) https://vox.com/world-politics/24128715/israel-palestine-conflict-settler-colonialism-zionism-history-debate.

30. Nadera Shalhoub-Kevorkian, "The Occupation of the Senses: The Prosthetic and Aesthetic of State Terror," *BRIT. J. CRIMINOL.* 57 (2017): 1281.

31. Gil Hochberg, *Visual Occupations: Violence and Visibility in a Conflict Zone* (Durham: Duke University Press, 2015), p. 3.

32. Ariella Azoulay, *From Palestine to Israel: A Photographic Record of Destruction and State Formation, 1947–1950* (London: Pluto, 2011), p. 214.

33. Abourahme, "In Tune with Their Time," p. 15.

34. John Berger, *and our faces, my heart, brief as photos* (London: Bloomsbury, 1984), p. 72.

35. John Berger, *Hold Everything Dear: Dispatches on Survival and Resistance* (New York: Vintage, 2007), pp. 13–26.

36. Isabella Hamad, "The Revolutionary Power of Palestinian Theater," (2023).

https://lithub.com/the-revolutionary-power-of-palestinian-theater

37. Fred Moten, "Not in Between: Lyric Painting, Visual History, and the Postcolonial Future," *The Drama Review* 47, no. 1 (T177), (Spring 2003): 132.

38. Quoted in Hammad, "Revolutionary Power."

39. Ruanne Abou-Rahme, quoted in Amal Issa, "Being in the Negative: An Interview with Basel Abbas and Ruanne Abou-Rahme," *Perpetual Postponement* (June 29, 2020). https://perpetualpostponement. org/being-in-the-negativean-interview-with-basel-abbas-and-ruanne-abou-rahme/.

40. Joe Sacco, "The War on Gaza." https:// the-comics-journal.sfo3.digitaloceanspaces. com/wp-content/uploads/2024/01/ SaccoGazaE010.png.

41. Arielle Angel, "We Cannot Cross until We Carry Each Other," *Jewish Currents* (October 12, 2023). https://jewishcurrents.org/ we-cannot-cross-until-we-carry-each-other.

42. David Marcus, "Persecution Terminable and Interminable," *Parapraxis*, (2024). https://parapraxismagazine.com/articles/ persecution-terminable.

43. Alexandra Juhasz, "Jew is . . . Jew Ain't," *Cultural Critique* (forthcoming, 2025).

44. Kaleem Hawa, "Zionism is the Catastro-phe," *People's Dispatch* (May 26, 2024). https://peoplesdispatch.org/2024/05/16/ zionism-is-the-catastrophe/

45. Echoing Jacques Derrida, *Specters of Marx* (New York: Verso, 1994), p. 9.

46. https://scalar.usc.edu/nehvectors/ how-to-see-palestine/index.

47. Mahmoud Darwish, "Think of Others," trans. Mohammed Shaheen, *The Gaza Reader Vol. 1. Poetry* (Venice: Artists Against Apartheid, Bidoun, WAWOG, the Kamal Lazar Foundation, and Palfest: 2024), p. 5.

48. On autotheory see Lauren Fournier, *Autotheory as Feminist Practice in Art, Writing, and Criticism* (Cambridge MA: MIT Press, 2021).

49. Walter Benjamin, *The Work of Art in the Age of Mechanical Reproduction*, trans. J. A. Underwood (Harlow: Penguin, 2008).

50. Aruna d'Souza, *Imperfect Solidarities* (New York: Floating Opera Press, 2024), pp. 15–20, 81–3.

51. Jill Casid, "Doing Things with Being Undone," *Journal of Visual Culture* 18, no. 1 (2019): 30–52.

52. https://oxfam.org/en/press-releases/daily-death-rate-gaza-higher-any-other-major-21st-century-conflict-oxfam.

53. Douglas Crimp, "Mourning and Militancy," *October* 51 (1989): 3–18.

54. Jill Casid, "Melancholy as Medium," Colloquium: "Exploring Indisposability: The Entanglements of Crip Art," eds. Jessica Cooley and Ann Fox, *Panorama: Journal of the Association of Historians of American Art* 8, no. 1 (Spring 2022): 1–2.

55. Simone Browne, *Dark Matters: On the Surveillance of Blackness* (Durham: Duke University Press, 2015), p. 16.

56. Hochberg, *Visual Occupations*, pp. 23–8.

57. Helga Tawil-Souri, "Qalandia Checkpoint as Space and Nonplace," *Space and Culture* 14, no. 1 (2011): 12.

58. Issam Nassar, Stephen Sheehi, and Salim Tamari, "Ways of Seeing the Palestinian Visual Archive," *Camera Palaestina: Photography*

and *Displaced Histories of Palestine* (Berkeley: University of California Press, 2022), p. 3.

59. B'Tselem, "Restrictions on Movement" (2017). https://btselem.org/topic/ freedom_of_movement

60. Helga Tawil Souri, "Digital Occupation: Gaza's High-Tech Enclosure," *Journal of Palestine Studies* XLI, no. 2 (Winter 2012): 27–43.

61. See Mirzoeff, *How to See the World*, pp. 163–210.

62. https://middleeasteye.net/news/ disturbing-recordings-crying-infants-played-israeli-quadcopters-lure-gaza-residents-shooting.

63. Yuval Abraham, "Lavender: The AI Machine Directing Israel's Bombing Spree in Gaza." *+972* (April 3, 2024). https:// 972mag.com/lavender-ai-israeli-army-gaza/.

64. Quoted by Abraham, "Lavender."

65. Sheera Frenkel, "Israel Deploys Extensive Facial Recognition Program in Gaza," *New York Times* (March 3, 2024). https://nytimes. com/2024/03/27/technology/israel-facial-recognition-gaza.html.

66. Mosab Abu Toha, "A Palestinian Poet's Perilous Journey Out of Gaza," *New Yorker* (December 25, 2023). https://newyorker. com/magazine/2024/01/01/ a-palestinian-poets-perilous-journey-out-of-gaza.

67. Seymour Hersh, "Torture at Abu Ghraib" *New Yorker* (April 30, 2004). https:// newyorker.com/magazine/2004/05/10/ torture-at-abu-ghraib.

68. https://nytimes.com/2024/06/06/world/ middleeast/israel-gaza-detention-base.html.

69. B'Tselem, "Establishing a 'Security Zone' in Gaza Is a War Crime," (2024). https://btselem.org/gaza_strip/20240221_establishing_so_called_security_zone_in_gaza_is_a_war_crime.

70. Jacques Rancière, *Dissensus: On Politics and Aesthetics* (New York: Continuum: 2010), p. 37.

71. Anne Michaels, *Fugitive Pieces* (New York: Farrar, Strauss and Giroux, 1996), p. 79.

72. Maha Nassar, "From the River to the Sea Doesn't Mean What You Think It Means," *The Forward* (December 2023). https://forward.com/opinion/415250/from-the-river-to-the-sea-doesnt-mean-what-you-think-it-means/.

73. Hito Steyerl, *Duty Free Art: Art in the Age of Planetary Civil War* (New York: Verso, 2017).

74. *Gaza Reader VOL 1. Poetry*.

75. *Nebula* (Venezia: Complesso dell'Opsedaletto, 2024), p. 15.

76. Leah Hunt-Hendrix and Astra Taylor, *Solidarity: The Past, Present, and Future of a World-Changing Idea* (New York: Knopf Doubleday, 2024), pp. xii–xvi.

77. See Nicholas Mirzoeff, *White Sight: Visual Politics and Practices of Whiteness* (Cambridge MA: MIT Press, 2023), pp. 1–28.

78. Clarence A. Robinson, "Surveillance Integration Pivotal in Israeli Successes," *Aviation Week* (July 5, 1982). https://archive.aviationweek.com/issue/19820705.

79. R. H. Spector, "Visual Fields," H. K. Walker, W. D. Hall, J. W. Hurst (eds.). *Clinical Methods: The History, Physical, and Laboratory Examinations*, third edition (Boston: Butterworths, 1990), Chapter 116. https://ncbi.nlm.nih.gov/books/NBK220/.

80. Jean-Pierre Filiu, *Gaza: A History* (New York: Oxford University Press, 2014), p. 316.

81. See https://youtube.com/watch?v=1FTaLFaj5rs.

82. Browne, *Dark Matters*, p. 16.

83. Anna Burns, *Milkman* (London: Faber & Faber, 2018), p. 89.

84. Megan Stack, "The View within Israel Turns Bleak," *New York Times* (May 16, 2024). https://nytimes.com/2024/05/16/opinion/israeli-palestine-psyche.html.

85. Frantz Fanon, *Wretched of the Earth* (New York: Grove Books, 2004), p. 6.

86. Ibid., p. 7.

87. Ibid., p. 13.

88. Fady Joudah, *[…]* (Minneapolis: Milkweed, 2024), p. 16.

89. Joudah, *[…]*, p. 3.

90. Alana Lentin, "Good Jew, Bad Jew," *Why Race Still Matters* (London: Polity Press, 2020), p. 134.

91. n+1, "Who Sees Gaza?" *n+1* 47 (Spring 2024): 9.

92. Christian Meyer, et al., *Intercorporeality: Emerging Socialities in Interaction* (Oxford University Press, 2017).

93. Sara Aziza, "The Work of the Witness," *Jewish Currents* (January 12, 2024). https://jewishcurrents.org/the-work-of-the-witness.

94. https://blackpast.org/african-american-history/combahee-river-collective-statement-1977/.

95. Ariel Goldberg, "If the Whole World Is Still Watching . . ." *Visual AIDS blog* (April 26, 2024). https://visualaids.org/journal/if-the-whole-world-is-still-watching.

96. Kari Paul, "Instagram Users Accuse Platform of Censoring Posts Supporting Palestine," *Guardian* (October 18, 2023).

https://theguardian.com/technology/
2023/oct/18/instagram-palestine-posts-
censorship-accusations.

97. Human Rights Watch, "Meta's Broken
Promises: Systematic Censorship of
Palestine Content on Instagram and
Facebook." https://hrw.org/report/
2023/12/21/metas-broken-promises/
systemic-censorship-palestine-content-
instagram-and.

98. https://aljazeera.com/news/2024/8/27/
did-bidens-white-house-pressure-mark-
zuckerberg-to-censor-covid-content.

99. Rachel Kuo and Sarah J. Jackson, "The
Political Uses of Memory: Instagram and
Black-Asian Solidarities," *Media, Culture &
Society* 46, no. 1 (2024): 165.

100. Ahmed Kabel, "Pedagogy and Epistemics
of Witness: Teaching Palestine in a Time of
Genocide" (May 12, 2024). https://
socialtextjournal.org/periscope_article/
pedagogy-and-epistemics-of-witness-
teaching-palestine-in-a-time-of-genocide/.

101. Arpan Roy, "The Burden of Witnessing,"
(April 15, 2024). https://socialtextjournal.
org/periscope_article/the-burden-of-
witnessing/.

102. Berger, *Hold Everything Dear*, pp. 13–15.

103. Walter Benjamin, "On the Concept of
History" (1940).

104. Mahmoud Darwish, "The Rose and the
Dictionary," *The Palestinian Wedding: A
Bilingual Anthology of Contemporary Palestinian
Resistance Poetry*, trans. A. M. Elmessiri
(Boulder, CO: Lynne Rienner Publishers,
2011), p. 31.

105. United Nations Environmental Program,
"Environmental Impact of the Conflict in
Gaza," (May 2024): 23. https://wedocs.

unep.org/bitstream/handle/20.500.11822/
45739/environmental_impact_conflict_
Gaza.pdf.

106. Yevgenia Belorusets, *Lucky Breaks* (New
York: New Directions, 2018), p. 7.

107. Berger, *Hold Everything Dear*, pp. 13–14.

108. Matic Broz, "How Many Photos Are There
(2024)?" https://phototutorial.com/photos-
statistics/.

109. John Berger, "A Moment in Ramallah: In
Palestine," *London Review of Books* (July 24,
2003). https://lrb.co.uk/the-paper/v25/
n14/john-berger/a-moment-in-ramallah.

110. Berger, *Hold Everything Dear*, p. 75.

111. Ibid., pp. 14–15.

112. Mahmoud Darwish, *Memory for Forgetfulness.
August, Beirut, 1982*, trans. Ibrahim Muhawi
(Berkeley: University of California Press,
2013), pp. 45–6.

113. Ibid., p. 49.

114. Berger, *and our faces, my heart, brief as photos*,
p. 14.

115. Christina Sharpe, *In the Wake: On Blackness
and Being* (Durham: Duke University Press,
2016), pp. 11, 131.

116. John Berger, "Al Rabweh," in Mahmoud
Darwish, *Mural* (New York: Verso, 2009),
p. 1.

117. Berger, "Al Rabweh," p. 4.

118. Ibid., p. 1.

119. Berger, *Hold Everything Dear*, p. 16.

120. See https://randamaddah.com/?page_id=
72.

121. Berger, "Al Rabweh," p. 7.

122. See exhibit site at https://palmuseum.org/
en/exhibitions-and-events/exhibitions/
not-exhibition.

123. "May Amnesia Not Kiss Us on the Mouth." https://mayamnesia.diaart.org/part-ii.

124. Nasser Abourahme, "Revolution after Revolution: The Commune as Line of Flight in Palestinian Anticolonialism," *Critical Times* 4, no. 3 (December 1, 2021): 446.

125. Stuart Hall, *Selected Writings on Marxism* (Durham: Duke University Press, 2021), p. 280. Antonio Gramsci, *Letters from Prison* (New York: Harper and Row, 1973), p. 159.

126. Rebecca Ruth Gould, "Legal Form and Legal Legitimacy: The IHRA Definition of Antisemitism as a Case Study in Censored Speech," *Law, Culture and the Humanities* (2018): p. 4.

127. See "Jerusalem Declaration Against Antisemitism," (2022). https://jerusalem declaration.org.

128. Diawara, "Glissant," p. 2.

129. Victor Jabotinsky, "The Iron Wall," (1920). https://jewishvoiceforlabour.org.uk/article/the-iron-wall-a-definitive-new-translation/.

130. Caroline Elkins, *Legacy of Violence: A History of the British Empire* (London: Vintage, 2022), p. 420.

131. Or Rosenboim, *Air and Love: A Story of Food, Family and Belonging* (London: Picador, 2024), pp. 87–8.

132. Ibid., 73.

133. Ibid., 85.

134. See Richard Beard, *Sad Little Men*: *How Public Schools Failed Britain* (London: Random House, 2021).

135. See Ian Pace, "Abuse in Music." https://ianpace.wordpress.com/.

136. Jane Wonnacott, *Everybody's Business: Keeping Children Safe in School*. A Serious Case Review into Events at St Paul's School (Richmond Upon Thames: Safeguarding Children Board, 2020), p. 17. https://kingstonandrichmondsafeguarding childrenpartnership.org.uk/media/cm5b1pjz/serious_case_review_into_events_at_st_paul_school.pdf.

137. Sharon Otterman and Hannah Dreyfus, "Michael Steinhardt, a Leader in Jewish Philanthropy, Is Accused of a Pattern of Sexual Harassment," *New York Times* (March 21, 2019). https://nytimes.com/2019/03/21/nyregion/michael-steinhardt-sexual-harassment.html.

138. David Cronin, "When Britain Turned Palestine into a Second Ireland," *Electronic Intifada* (December 15, 2017). https://electronicintifada.net/blogs/david-cronin/when-britain-turned-palestine-second-ireland.

139. Elkins, *Legacy of Violence*, p. 230.

140. David Rooney, *Wingate and the Chindits* (London: Cassell Military Paperbacks, 1994), pp. 7–17.

141. Elkins, *Legacy of Violence*, p. 228.

142. Jonathan Fenby, *Crucible: Thirteen Months That Forged Our World* (London: Simon & Schuster, 2018).

143. Hussein Omar, "Homo Zion: How Pinkwashing Erases Colonial History," *Parapraxis*. https://parapraxismagazine.com/articles/homo-zion#_ftn2.

144. Elkins, *Legacy of Violence*, p. 202.

145. Ibid., p. 218.

146. Sam Harris, "5 Myths about Israel and the War in Gaza." https://samharris.org/blog/5-myths-about-israel-and-the-war-in-gaza.

147. Lana Tatour, "How Human Rights Organizations Are Aiding the Israeli Assault on Gaza," *Mondoweiss* (December 12, 2023). https://mondoweiss.net/2023/12/how-human-rights-organizations-are-aiding-the-israeli-assault-on-gaza/.

148. *Mission Report. Official Visit of the Office of the SRSG-SVC to Israel and the Occupied West Bank. 29 January–14 February 2024* (New York: 2024).

149. Sarah Ihmoud, "The Cunning of Gender Violence in Israel's War on Palestinian Women," *Jadaliyya* (April 3, 2024). https://jadaliyya.com/Details/45884/The-Cunning-of-Gender-Violence-in-Israel's-War-on-Palestinian-Women.

150. Andrew Motion, "A Boyhood Built on Fear," *New Statesman* (March 20, 2024). https://newstatesman.com/culture/books/book-of-the-day/2024/03/charles-spencer-boyhood-fear-andrew-motion.

151. https://theguardian.com/education/2024/mar/27/edinburgh-academy-john-brownlee-abuse.

152. Patrick Kingsley, "As World's Gaze Shifts to Gaza, Israel's Psyche Remains Defined by Oct. 7 Attack." *New York Times* (Dec. 26, 2023). https://nytimes.com/2023/12/26/world/middleeast/israel-netanyahu-politics-mood.html.

153. Dorit Rabinyan, "The Day Israel Banned My Book from Schools," (2017). https://time.com/4754208/all-the-rivers-dorit-rabinyan-book-ban/.

154. Dorit Rabinyan, "Who Are We Now?" *The Tablet* (2023). https://tabletmag.com/sections/arts-letters/articles/who-are-we-now.

155. Diawara, "Glissant," p. 2.

156. Houria Bouteldja, *Whites, Jews and Us* (Los Angeles: Semiotext(e), 2016), p. 34.

157. Claire Fontaine, *Human Strike* (Los Angeles: Semiotext(e), 2020), p. 114.

158. See exhibit listing: https://hauserwirth. com/hauser-wirth-exhibitions/cindy-sherman/.

159. Derrida, *Specters of Marx*, p. xv.

160. Sayek Valencia, *Gore Capitalism* (Los Angeles: Semiotext(e), 2018), p. 9.

161. Maya Pontone, "Pro-Palestine Activists Slash Portrait of British PM Associated with Nakba," *Hyperallergic*, (March 8, 2024). https://hyperallergic.com/876693/ pro-palestine-activists-slash-painting-of-former-british-prime-minister-arthur-balfour/.

162. Elkins, *Legacy of Violence*, pp. 178–80.

163. Dionne Brand, *A Map to the Door of No Return: Notes to Belonging* (Toronto: Vintage Canada, 2023), p. 4.

164. Nicholas Mirzoeff, *The Right to Look: A Counterhistory of Visuality* (Durham: Duke University Press 2011), p. 1–25.

165. Mirzoeff, *White Sight*, pp. 19–21, 228–32.

166. Priyamvida Gopal, *Insurgent Empire: Anticolonial Resistance and British Dissent* (New York: Verso, 2020), p. 111.

167. John Ruskin, *The Elements of Perspective* (London: Smith, Elder and Co., 1859), p. 3.

168. John Ruskin, *Lectures on Art* (Oxford, Oxford University Press), p. 29.

169. Ben Luke, "'At the Heart of All This is the Question of Power': Sonia Boyce on the Notorious Hylas and the Nymphs Takedown," *Art Newspaper* (March 29, 2018). https://theartnewspaper. com/2018/03/29/at-the-heart-of-all-this-is-the-question-of-power-sonia-boyce-on-

the-notorious-hylas-and-the-nymphs-takedown.

170. National Portrait Gallery, "Votes for Women" exhibit wall text (2019).

171. Quoted by Emily Davison Lodge, "Sylvia Pankhurst Memorial Lecture," (January 2014). https://sylviapankhurst.gn.apc.org/wp-content/uploads/2023/01/2014-lecture-for-website.pdf.

172. Emily Davison Lodge, "Pankhurst."

173. Elkins, *Legacy of Violence*, p. 178.

174. Gopalan, "After the Encampments."

175. See Marisa Holmes, *Organizing Occupy Wall Street: This Is Just Practice* (Brooklyn: Palgrave Macmillan, 2023).

176. https://steinhardtfoundation.org/our-vision/.

177. Fanon, *Wretched of the Earth*, p. 15.

178. See Greg Donahue, "Crime of the Centuries," *New York* (February 15, 2023). https://nymag.com/intelligencer/article/michael-steinhardt-antiquities-stolen-artifacts.html.

179. Basel Abbas and Ruanne Abou-Rahme, *And Yet My Mask Is Powerful* (New York: Printed Matter, 2017).

180. "D. A. Bragg: 39 Antiquities Valued at More Than $5 Million Repatriated to the People of Israel" (March 22, 2022). https://manhattanda.org/d-a-bragg-39-antiquities-valued-at-more-than-5-million-repatriated-to-the-people-of-israel/.

181. Annie Paradise, *The War on the Social Factory: The Struggle for Community Safety in the Silicon Valley* (Evanston IL: Northwestern University Press, 2024), p. 216.

182. Manuel Callahan, *Convivial Research* (San Francisco: CCRA, 2018).

183. Paradise, *The War on the Social Factory*, p. 3.

184. David Harvey, "The Right to the City," *New Left Review* 53 (September/October 2008).

185. Abourahme, "Revolution after Revolution," p. 447.

186. Grace Lee Boggs and Scott Kurashige, *The Next American Revolution: Sustainable Activism for the Twenty-First Century* (Berkeley: University of California Press, 2012).

187. See Kristin Ross, *Communal Luxury: The Political Imaginary of the Paris Commune* (New York: Verso, 2015).

188. Gilles Deleuze and Felix Guattari, *A Thousand Plateaus* (London: Continuum, 2004), p. 9.

189. Mat Fournier, "Lines of Flight," *TSQ* 1, no. 1–2 (May 1, 2014): 121–2.

190. Abourahme, "Revolution after Revolution," p. 448.

191. Ibid., p. 458.

192. https://platypus1917.org/2012/01/31/interview-with-david-graeber/.

193. Abourahme, "Revolution after Revolution," p. 464.

194. Holmes, *Organizing Occupy Wall Street*, pp. 64–6.

195. Casid, "Doing Things with Being Undone," p. 34.

196. Enzo Traverso, *The Jewish Question: History of a Marxist Debate*, trans. Bernard Gibbons (Leiden: Brill, 2019).

197. Daniel J. G. Pearce et al., "Role of Projection in the Control of Bird Flocks," *PNAS* 111, no. 29 (July 22, 2014): 10423.

198. Ruth Wilson Gilmore, *Abolition Geography: Essays toward Liberation* (New York: Verso, 2022), p. 490.

199. Jacqueline Rose, "What More Could We Want of Ourselves!" *London Review of Books* 33, no. 12 (June 16, 2011).

200. Rosa Luxemburg, *The Letters of Rosa Luxemburg* (New York: Verso, 2011), pp. 239–40.

201. Rosa Luxemburg, "In a Revolutionary Hour, What Next?" *The Complete Works of Rosa Luxemburg, vol. IV, Political Writings 2: On Revolution 1906–1909* (New York: Verso, 2023), pp. 139, 141.

202. Luxemburg, *Letters,* February 16, 1917, pp. 375–6. This translation is updated from the one Rose used.

203. Quoted by Sven Lindqvist, *"Exterminate All the Brutes"* (London: Granta, 2018), p. 140. See pp. 140–51 for more details on the extermination/extinction paradigm.

204. Luxemburg, *Letters*, August 31, 1915, p. 353.

205. Ibid., before December 24, 1917, p. 455.

206. Jackie Wang, *Carceral Capitalism* (Los Angeles: Semiotext(e), 2018), pp. 298, 302, 306–7.

207. Luxemburg, *Letters*, November 10, 1914, p. 343.

208. Paul Frölich, *Rosa Luxemburg* (Chicago: Haymarket Books, 2010), pp. 291, 294.

209. See John Berger, "A Gift for Rosa," *Confabulations* (New York: Penguin, 2016), pp. 9–23.

210. Luxemburg, *Letters*, Aug. 27, 1917, p. 439. Peter Kropotkin, *Mutual Aid* (Oakland CA: PM Press, 2021), pp. 54–5.

211. Mickey Vallee, "Animal, Body, Data: Starling Murmurations and the Dynamic of Becoming In-formation," *Body and Society* 27, no. 2 (2021): 86.

212. Amilcar Cabral, "The Weapon of Theory," *The Journal of Pan African Studies* 3, no. 5 (December 2009): 1–16.

213. Stephano Harney and Fred Moten, *All Incomplete* (Brooklyn NY: Minor Compositions, 2021), pp. 147–51.

Thanks to our Patreon subscriber:

Ciaran Kane

Who has shown generosity and
comradeship in support of our publishing.

Check out the other perks you get by subscribing
to our Patreon – visit patreon.com/plutopress.
Subscriptions start from £3 a month.

The Pluto Press Newsletter

Hello friend of Pluto!

Want to stay on top of the best radical books
we publish?

Then sign up to be the first to hear about our
new books, as well as special events,
podcasts and videos.

You'll also get 50% off your first order with us
when you sign up.

Come and join us!

Go to bit.ly/PlutoNewsletter